LOCUS SOLUS ↘

site, identity, technology in contemporary art

JULIAN STALLABRASS

PAULINE VAN MOURIK BROEKMAN

NIRU RATNAM

4

PREFACE

JON BEWLEY +
SIMON HERBERT

In 1996 artist Richard Wilson proposed to 'draw' the main elevations of the north facade of the Baltic Centre for Contemporary Art in neon tubes, superimpose an identical schematic tilted at a different angle and alternate between the two using a random switching system; thereby creating the illusion that the building—at that time awaiting the beginning of construction work—was about to become so charged that its internal energies would literally allow it to temporarily escape the effects of gravity. *The Joint's Jumping* was intended to announce the arrival of the biggest lottery capital project in the north east of England.

In 1997 Chinese Canadian artist Paul Wong filled the grand French windows of the classical and richly decorated Nash Room at the Institute of Contemporary Art with large digitally enhanced portraits of Chairman Mao and Queen Elizabeth II. Between them stood a stack of flickering neon symbols: the Union Jack, Chinese calligraphy, bowls of rice, an AK47 automatic rifle. If the viewer left the building and stood outside on the Mall (the main thoroughfare leading to Buckingham Palace, visible on the horizon), a reverse perspective afforded the view of the windows blocked out in the three colours of the Irish tricolour.

In 1998 Cathy de Monchaux, an artist known principally for her gallery-based works, produced a permanent large-scale photowork. Covering one complete wall of the entrance to Cullercoats Metro Station, a stop on the Tyne and Wear Metro System, it depicts a red welcome carpet spiralling onto the tracks of a deserted and unnamed station. Barely visible are the lights of a train receding into the distance, disappearing into the mesh of perspective lines that seem to extend into the three-dimensional platform. A grid of protective perspex panels reflect the stares of commuters, placing them within her melancholic image.

In 1999 Laura Vickerson worked with members of the Sedbergh Stitchers, a women's group based in the picturesque market town in Cumbria, to produce a twenty-metre-long cape and hood consisting of hundreds of thousands of red rose petals pinned individually by hand onto an organza train. The artwork, which extended throughout the whole top floor of Farfields Mill (a working mill until 1996), was premiered to the local community when Vickerson opened the annual Spring Show as Guest of Honour.

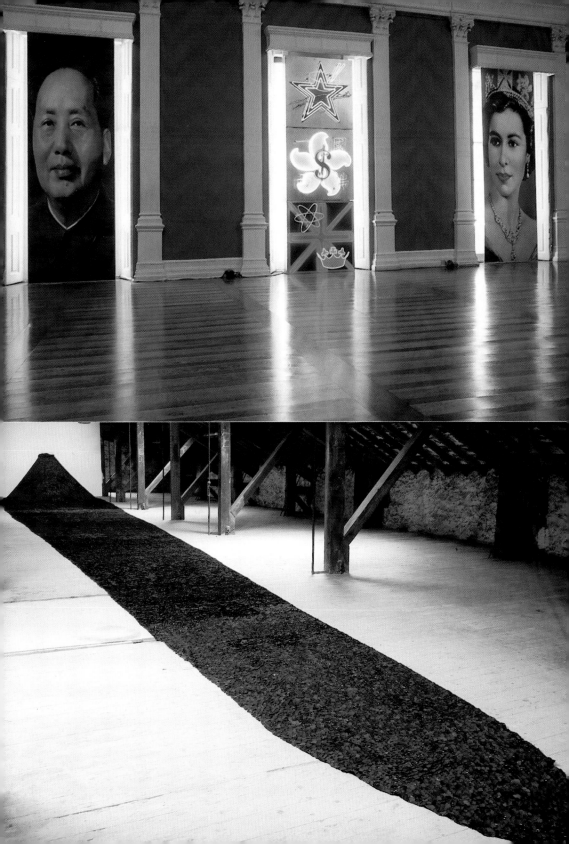

What connects these projects? It is possible to find commonalities, such as an artist's use of materials—neon in the case of the first two —or imagery—a large red slash in the case of the latter two; but such correlations are circumstantial rather than premeditated. If anything, the differences between each project are more evident than their similarities. Some works insinuate themselves simply via their inert presence in communal space, whilst others require a level of active participation in the actual fabrication process incongruous with a passive response. Some hint at hidden narratives of specific sites, whilst others engage with more formal aspects and critiques. Consider any other factors—the specific intentions of the artists, say, or a use of scale, or the different pathologies of the temporary and the transient—and it becomes apparent that any aggregate associations are seemingly arbitrary. Consider also that these are only four examples of projects curated by Locus+. Factor in an additional thirty-two artists projects, the dissemination of eighteen publications (ranging from catalogues, simulacra of Irish parliamentary documents through to audio CDs) and nine artists' multiples that the organisation has commissioned since its formation in early 1993, and the existence of a conceptual through-line becomes even harder to envisage (a full list of Locus+ projects follows on p.136).

At a time when arts organisations are increasingly rationalising their operations, it may seem contrary that Locus+ continues to develop a commissioning policy that results in no one year of projects resembling another. Yet it would be disingenuous to imply that there is no consistent methodology used by the organisation; and the clue to this lies in the name Locus+. The definition 'locus' in legal terms is "... a place or area where something has occurred...", and, even more aptly, in mathematical terms, is "... a set of points or lines whose location satisfies or is determined by one or more specified conditions..."; and this location is an endlessly evolving and complex 'place' of many parts: historic, cultural, economic, psychological or technological. The '+', the one constant that lies at the point of triangulation between these vastly different projects, is the positive presence and catalysing role of the artist with participating partners. The responsibilities and actions of the artist remain a fixity, the calm eye at the centre of the storm of negotiation, arbitration, and contextualisation. A reliance on the artist to catalyse and define the initial parameters of a project is not the norm in terms of the UK art scene, which tends to favour the needs of the institution first. The bureaucratic response tends to perceive the prioritisation of artists as problematic, at the very least logistically, in that to realise an idiosyncratic vision necessitates the reinvention of the wheel each time; an approach that does not sit well with operational guidelines that increasingly conform to fixed measures of assessment. Locus+, however, perceives the prospect of having to secure different sites, with a different set of audiences, and a different set of contextualising factors, as an opportunity to constantly redefine those elements that are integral to a project in a qualitative manner, rather than just ticking off the boxes that justify access to the public purse.

previous pages
left above
Richard Wilson. *The Joint's Jumping*, computer generated image/proposal for the Baltic Centre for Contemporary Art, Gateshead, Tyne and Wear, 1996. © Richard Wilson.

left below
Cathy de Monchaux. *The Day Before You Looked Through Me*, Cullercoats Metro Station, Tyne and Wear, 1998. Photo: Steve Collins.

right above
Paul Wong. *Windows 97*, ICA London, 1997. Photo: Stephen White.

right below
Laura Vickerson. *Fairy Tales & Factories*, Farfields Mill, Sedbergh, 1999. Photo: Steve Collins.

This methodology is also a partial acknowledgement that the brittle definitions between visual art culture and other disciplines continue to break down further into states of hybridity—whether this be in relation to fashion, design, architecture, film, music or further challenged by the steady growth of electronic imaging and information systems. Locus+ itself continues to change as an organisation. We are increasingly being invited to curate projects for permanent contexts (which is a move not necessarily away from, but certainly tangential to, our history of temporarily occupying sites). The accomplishment of certain new works demand that additional skills and patiences be developed, and new and complex alliances be forged. Such relationships are often fragile, and there is a tacit acknowledgement that a strategic project can be worked on for extended periods with no guarantee of final realisation (as was the case with Richard Wilson's *The Joint's Jumping*, which did not progress beyond its two-year development stage). Curiously, Locus+ now finds itself perceived simultaneously by some as an institution and by others as an independent unit. The truth lies somewhere between the two, and the publication of this book is an attempt to illuminate this. *Locus Solus* is not, however, an articulation of an organisation, but concentrates on a number of prevailing issues explored by a diverse range of critics, writers and practitioners. The fact that any number of projects mentioned within could (and occasionally do) appear concurrently under the headings of Site, Identity or Technology reflects a concomitant fluidity. The artworks have provided a springboard for the writers to consider broader issues beyond the localised conditions of any one project.

The title *Locus Solus* refers, in the first part to Locus+, but also to the novel of the same name—first published in 1914 by the French proto-Surrealist Raymond Roussel.[1] The additional "Solus" (in Latin meaning "alone" or "by oneself") in conjunction with Locus, produces the definition "solitary or unique place". Roussel's fictitious creation, the scholarly scientist Canterel, has used his enormous wealth to create a secluded estate near Paris. The villa Locus Solus contains many rooms fitted out as luxurious model laboratories, each room part of an exhibition that demonstrates and expounds the discoveries and inventions of his fertile, encyclopaedic mind.

1 Roussel, Raymond, *Locus Solus*, trans. Rupert Copeland Cuningham, London: John Calder, 1983 edition.

This publication substitutes Canterel's display of (amongst other things): African mud sculptures; a road-mender's tool which when activated by the weather, creates a mosaic of human teeth; and a vast aquarium in which human beings can breathe, for a floating buoy cast from the metal of decommissioned Russian submarines, wending its solitary way across cold oceans back to the shipyards from which it sprang; Santeria altars carried in torchlight procession through slaving ports and lowered into harbour waters as the wails of Yoruban keening echo around the docks; a work of art that ran in the 1994 flat season; and a sculpture of a lupine child that moves almost imperceptibly, of its own volition, in a landscape touched by technology and rich in metaphor and myth.

SITE

MEMORIES OF ART UNSEEN

JULIAN STALLABRASS

As with certain fine wines that were improved by travel, sent on long sea voyages that ended where they began, there is an often unacknowledged feeling that works of art gain some further flavour from touring, beyond the ratification given by an airing in prestigious international venues, the names of which cling to the work like stickers to a suitcase.

From what basis does that feeling launch itself into the consciousness of art-lovers? There is first the opinion that travel is good for people too, since travel, romance and the love of art accompany one another, making of minds dulled by routine sharp aesthetic and erotic receptors.[1] Thus the most developed cultured cosmopolitan types must spend their time hopping between the world's great art centres and the further flung biennials where familiar venues and works are made to rub up against each other and, in the resulting friction, alter one another. In this transaction—as in travel for the sake of it—time and space are knotted tightly together. The unfurling of space in travel possesses the powers usually ascribed to the passage of time, engendering forgetfulness and returning the voyager to an unattached state: "Time, we say, is Lethe; but change of air is a similar draught, and, if it works less thoroughly, does so more quickly."[2] In a still modernist compact, vagabond meaning, cultivated in the paradox-spinning common to contemporary art, finds a warm welcome in the mind of the wandering aesthete. It is the greeting of two exiles, travelled far from domestic bonds of affection and restriction.

1 On this subject, see the beautiful passages in Ernst Bloch, *The Principle of Hope*, trans. Neville Plaice, Stephen Plaice and Paul Knight, Cambridge, MA: The MIT Press, 1995, pp. 370f.

2 Mann,Thomas, *The Magic Mountain* [1924], trans. H.T. Lowe-Porter, Harmondsworth: Penguin, 1960, p. 4.
In classical mythology, Lethe is the river of forgetting.

Indeed, as described by Ernst Bloch in his epic meditation on *The Principle of Hope*, travel, with its continual parade of novelty, transforms time and space together. It brings about a subjective spatialisation of time and a temporalisation of space in which time becomes filled with detail in the way that space is usually filled, and space becomes the medium of change that time usually is. Such a transformation, says Bloch, is like the month of May which makes everything anew, and for the bourgeois private world, it is the only renewal available.[3]

3 Bloch, *Hope*, p. 371.

These broad considerations apply as much to art shown in regional centres as that seen in the major art capitals and the foremost international exhibitions. The distances travelled (at least by the audience) may average less, but may feel as significant; the works of art displayed may be no more at home.

Wherever art is shown, we should ask: what is the life of those works for the great majority who only encounter them second-hand? How many more people, for instance, have heard about, read about and seen in reproduction fragments of Gerhard Richter's *Atlas* than have perused it face-to-face on one of its international outings? The same may be said for some of the artists dealt with by Locus+—for instance, of the whistling kettles, decaying blooms, whitening chocolate walls and dissolving estuary columns of Anya Gallaccio. In addition, some works make a virtue of their invisibility to the general public.[4] Stefan Gec's *Buoy* has become a roving nautical instrument, its 'irradiated' shell living for all but passing seafarers solely in the mind. While these works make a theme of their own invisibility, most are not like that. Rather, they display themselves in particular places for particular audiences, striving to change themselves, the venues and their viewers and then to move on.[5] Nevertheless, in both cases—visible or largely invisible— works of art have by far their greatest reception second-hand.

4 On Gallaccio's work, see *Chasing Rainbows*, Newcastle upon Tyne: Locus+/ Tramway, 1999.

5 See, for instance, the accounts given of Lloyd Gibson's work *Crash Subjectivity* on its various displays in Newcastle, Belfast and Dublin by Jon Bewley and Simon Herbert, eds., *The Perplexities of Waiting: Crash Subjectivity, 1993-95, Lloyd Gibson*, Newcastle upon Tyne: Locus+, 1995.

To return to the question, then: what life does the art work have for those who do not directly experience it, what memories do they carry with them of art unseen? In trying to find an answer, we will highlight the entanglement of the passage of time and the experience of space, and take a few brief journeys, some of which may have the appearance of detours.

TIME AND SPACE

First, we should consider, briefly and at the highest level of generality, the interrelation of time and space in culture and memory. In making memories, our minds make spatial forms out of temporal sequences, preserving time only by fixing it in space. The ancient tricks of memory enhancement involved the mental construction of an architecture and the placement in its niches or between its columns of striking, mind-prompting images.[6] Modern mnemonists have evolved similar techniques that have, for instance, involved imagining a walk down some city street, placing 'objects' in doorways or against walls; to remember a sequence of words or numbers, even years later, it is enough to walk once again down that same street.[7] Such aids aside, our regular experience of memory feels more spatial than temporal, a layering of veils distant and near, which has its own spatial organisation

6 Yates, Frances A., *The Art of Memory*, London: Pimlico, 1996, passim.

7 See, for instance, the remarkable account of synaesthetic memory in A.R. Luria, *The Mind of a Mnemonist: A Little Book about a Vast Memory*, Harvard: Harvard University Press, 1986.

opposite
Lloyd Gibson. *Crash Subjectivity*, Newcastle upon Tyne, Belfast and Dublin, 1993-95
Photo & © Lloyd Gibson.

independent of temporal contiguity. As Proust, that most assiduous student of memory, describes it:

> Have we not often seen, in a single night, in a single minute of a night, remote periods, relegated to those enormous distances at which we can no longer distinguish anything of the sentiments which we felt in them, come rushing upon us with almost the speed of light as though they were giant aeroplanes, instead of the pale stars which we had supposed them to be, blinding us with their brilliance and bringing back to our vision all that they had once contained for us, giving us the emotion, the shock, the brilliance of their immediate proximity, only, once we are awake, to resume their position on the far side of the gulf which they had miraculously traversed...?[8]

In more material terms, when memories are made, pathways of protein are laid down in the brain—a network of learning—and that activity, and the amounts of protein involved, can be measured.[9] Without sufficient intake of protein, the mind lies undeveloped as surely as the body. So in extreme circumstances even the most personal and internal matters—those of memory and thus of individual identity—are subject to economic forces, and the power struggles attendant upon them.

The numerous forms of artificial memory, too, transform time into space—the library, the filing cabinet and the archive as much as the hard disk and other digital storage media (though with the latter a logically organised visual interface conceals another principle of spatial ordering beneath, one less amenable to human recognition). As has often been brought out in historical and theoretical writing, these collective apparatus of memory are bound up with political power, the archive originally residing in the hands of state authorities who both controlled access to records and sanctioned their interpretation.[10]

Against this work of memory, individual and collective, that spatialises time, there are forces that push in the opposite direction, continually throwing fixed structures into chaos. These are the sovereign powers of commerce on which so much that is valued and thought of as settled is continually sacrificed. As Marx and Engels put it in a famous passage, of economic and technological forces that are now more familiar but also more powerful and ubiquitous:

> Constant revolutionising of production, uninterrupted disturbance of all social conditions, everlasting uncertainty and agitation distinguish the bourgeois epoch from all earlier ones. All fixed, fast-frozen relations, with their train of ancient and venerable prejudices and opinions, are swept away, all new-formed ones become antiquated before they can ossify. All that is solid melts into air...[11]

The authors believed that in and of itself this process would ensure that people would confront the actual conditions of their lives, not foreseeing that new mythologies would spring up to replace the old, and that some—perhaps, above all, the appeal to art's eternal spirit—would acquire a particular durability.

8 Proust, Marcel, *Remembrance of Things Past*, vol. 3, trans. C.K. Montcrieff and Terence Kilmartin, Harmondsworth: Penguin, 1983, p. 950.

9 Rose, Steven, *The Making of Memory: From Molecules to Mind*, Toronto: Bantam, 1993, passim.

10 On the latter point, see Jacques Derrida, *Archive Fever. A Freudian Impression*, trans. Eric Prenowitz, Chicago: University of Chicago Press, 1997, p. 2.

11 Marx, Karl and Frederick Engels, *The Communist Manifesto: A Modern Edition*, London: Verso, 1998, pp. 38 and 39.

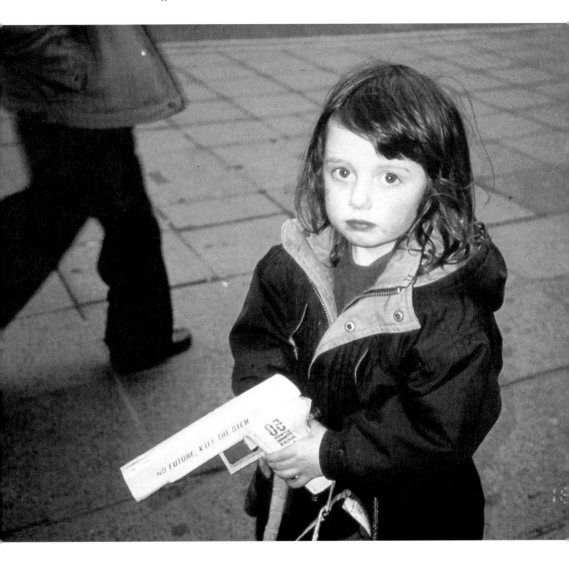

Economic forces exploit differences marked spatially, sometimes to make those differences more pronounced; sometimes, in the process of exploiting them, to efface them. Against the spatially congealed forms of collective memory are pitched the forces of entrepreneurial flux that would tear them down. Consider the difference between those cities that are the centres of economic turmoil and runaway growth (urban centres in China and Southeast Asia that until the recent crash ruthlessly remade their structures every few years) and those places which for political reasons have for a time become economic backwaters (Havana or Famagusta, for example) becalmed in dusty, if dignified and historic, stasis. Equally, those forces bear on individuals, forcing or luring them from familiar environs, thrusting them in their millions into migrations, regional (from the north to the south of England, say) and across

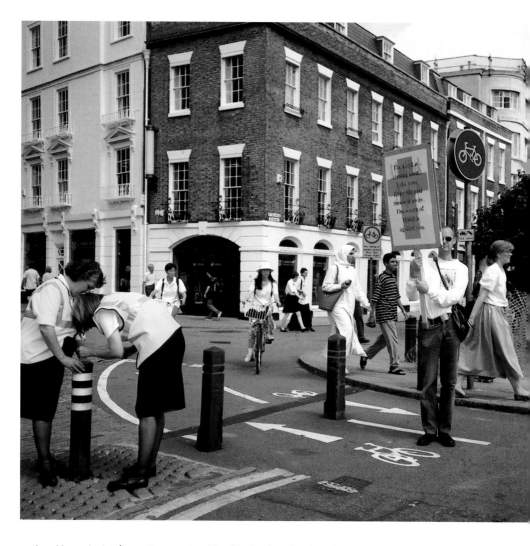

national boundaries (from the countryside of Ireland to the city of Newcastle, or from the Philippines to Saudi), with all the compensatory forms of memory, community, culture and national politics that such movements regularly induce.[12]

AN ODD COMMODITY

What role do works of art play within this opposition—for the moment too crudely drawn—of the spatial impetus of memory, and the disruptive temporal flux of trade, technology and migration? The circulation of art works is a curious matter, as art works are themselves curious commodities. Often, of course, that circulation takes place to achieve a sale, but our concern here is more the temporary display of a work to the general public in a particular locale. Such works are not, like most commodities, consumed but are instead preserved (although there are exceptions which we will look at shortly). Both factors—display without

12 Benedict Anderson has written eloquently on this subject. See, for instance, his *The Spectre of Comparisons: Nationalism, Southeast Asia and the World*, London: Verso, 1998, especially chapter 3. A brief history of Irish immigrants in the north east of England accompanied an exhibition of the work of Shane Cullen in Newcastle. See John Corcoran, "*The Irish on Tyneside and the North East: An Integral Part of a Region's Identity*", in Jon Bewley and Simon Herbert, eds., *Shane Cullen: Fragmens sur les Institutions Républicaines IV (Panels 1-48)*, Newcastle upon Tyne: Locus+, 1996.

sale, and preservation rather than consumption—tend towards spatial fixity as against temporal flux. While achieving a temporary transformation of a particular area, the works place themselves on the side of memory as against dizzying change.

It is a much-honoured convention among artists and those who write in the support of art to pay homage at the twin temples of indeterminacy and hybridity, celebrating the broad cultural phenomena—if not directly the material forces—that allow one to enjoy Lebanese cuisine in London, or Vietnamese in Paris. The homage is attached as much to works that are strapped with conceptual and physical bonds to one place as for those that can be packed in a crate and shipped anywhere. Strangely, at the birth of immobile works—those that reflected on site, on the specific features of a certain place—in an art still illumined by the fading light of modernism, there was a similar celebration of the falling away of fixed categories: for Robert Smithson, faced with the strange shore of the salt lake that would become the scene for *Spiral Jetty*:

> My dialectics of site and nonsite whirled into an indeterminate state, where solid and liquid lost themselves in each other. It was as if the mainland oscillated with waves and pulsations, and the lake remained rock still. The shore of the lake became the edge of the sun, a boiling curve, an explosion rising into a fiery prominence. Matter collapsing into the lake mirrored in the shape of a spiral. No sense wondering about classifications and categories, there were none.[13]

13 Smithson, Robert, "The Spiral Jetty" (1972), *Theories and Documents of Contemporary Art: A Sourcebook of Artists' Writings*, Kristine Stiles / Peter Selz, eds., Berkeley: University of California Press, 1996, p. 532.

Site specificity, then, was born at a place that could not conventionally be seen as a place. Yet, aside from the fact that the insistent assertion of a claim to indeterminacy or liminality can reinforce the policing of conceptual boundaries and of difference, for all the content of conventional contemporary works (and the overtly hybrid sculpture of Lloyd Gibson can serve as a model here), the form of the work—whether circulating unchanged and intact, or tied to one location—tends to fixity.

COUNTER-CURRENTS

This basic opposition of commerce and memory is, of course, too simple, for countervailing currents run through the broad opposing tides of fixity and mobility. The swift and disorienting movements of people, goods and information (much of it cultural) provoke compensatory attachments to older political, social and cultural forms, which, although they are reinvented for the benighted present, are packaged as a return to past purity, and as a bulwark fixed once and for all against the flow of time. Such reactions are not necessarily fastened upon the conventional forms of identity politics: the preachers recorded on the streets of Nottingham by Virgil Tracy, in their objections to homosexuality, feminism, promiscuity and the sanctities of mainstream politics powerlessly protest against a flow of social change that has left them stranded.[14]

14 Tracy, Virgil, *A Good Book*, Newcastle upon Tyne: Locus+, 1994.

opposite
Virgil Tracy. *A Good Book*, 1994.
Photo: Chris Dorley-Brown
© Virgil Tracy.

Equally, commerce seizes on marketable ancient fixity—condensed in that invidious word 'heritage'—with the same fiction that the past is brought unchanged into the present, though in fact it must be constantly remade to meet the demands of fleeting and easily distracted buyers.

Thus museums and galleries, once reliable repositories of static memory in which 'old friends' could always be found in their familiar places on repeated visits—so that in the mind building and contents grew together, united in assuring the viewer of constancy and profundity—now continually shuffle their displays. (Think, for example, of the Tate Gallery which shows only a small part of its permanent collection at one time in seasonal, sponsored 'new displays', and also cycles it between different buildings in London, Liverpool and St. Ives. A work by Ben Nicholson, for example, will take on a markedly different flavour in Cornwall than in the capital, in the former tending to provincial landscape, in the latter to European modernism.) Moveable, and sufficiently sturdy, works of art no longer have homes but in their circulation from place to place (even within the same building) are meant to gain from travel and a change of neighbours, just as tourism brings about a new May for the weary bourgeois. So the buildings alone endure, solitary sites of space and memory—and this is the cause of the muscular and sometimes overbearing charisma of contemporary museum and gallery architecture, often more celebrated than its shifting contents.

Why the continual shuffling of displays? In part, because of the demands of the market that forces time upon objects with its incessant urge to novelty. In part, because of a change in the character of many works themselves, in response to and in anticipation of such treatment: they must make their points quickly and with immediate impact, and draw upon the techniques of advertising and the mass media to do so.[15] For much art made today, it is hardly necessary to see it. Many works operate rather like crossword clues, being collages of ready-made images and ideas, so that a reproduction and a description can impart the general idea. Since the general idea is the core of the work, sensuous and especially unreproducible impressions and inflections add little.

15 The striking example here is so-called 'young British art', though the phenomenon certainly extends beyond these shores. See my book *High Art Lite: British Art in the 1990s*, London: Verso, 1999.

Sometimes you see bands from Eastern Europe, playing on ferries, perhaps, to semi-captive audiences—ferociously efficient combos, working their way with equal despatch through a wide range of Western popular music. Then some oddity in the singer's intonation (like that of a child reading a complex passage) draws you up short, with the realisation that the words sung are mere sounds for the singer and the band, reconstructed from recordings without comprehension. The making of these songs is a little like reverse-engineering—the taking apart of a mechanism you want to replicate, starting not with a blank sheet of paper and some desire or inspiration but with the completed device.

How can we know that many of the art works we see—first- or second-hand—hedged about with institutions that foster, protect and restrict them, are not similar? Lacking the betrayal of uncomprehending intonation, expecting in any case a certain irregularity as a regular feature of the art work, can we tell? Sometimes—though this can only be a superficial impression—works become too well-worn by travel, reproduction and brief exposure (as paintings hung in public galleries pale slowly under the built-in flash-guns of compact cameras).

Yet, fresh or faded, reverse-engineering is as much a matter for the viewer as for the creator. Writing in support of art often leans heavily upon stories about the artist and the creation of the work, seeking to convince the reader of the work's integrity (or sometimes of a principled rejection of integrity) but that insistence upon the genesis of the work has nothing to say about its reception. If works seen and read about second-hand are reverse-engineered in the imagination, perhaps that process is not so different from that which takes place in front of the original work itself.

SITE-SPECIFICITY

As with the broad operation of collective memory, the effect of art works upon flux and memory has contradictory aspects. On one hand, it can act—and sometimes does so consciously—as compensation for the action of commerce that has wiped out the redoubts of culture and attachment with its endless waves, smoothing the shore in ensuring for itself an uninterrupted path. Such art is in the business of recovering histories, restoring identities and rebuilding old narratives fit for the present, though (depending on how it is looked at) the resistant particles of excavated history may also appear as yet another wave of commerce. Regional arts organisations, lacking the pretension to universality of the cosmopolitan centres, often exploit the particularities of their specific locale, so that Liverpool which once profited greatly from slavery, now profits slightly from its memory. On the other hand, works of art may serve to more effectively inter the past, freezing it in forms concrete and immovable, funerary monuments that brand a site with their identity (thus Antony Gormley's rusty erection, *Angel of the North*, that comes to bury the old industry of the Northeast in the act of praising it—subverted in Paul St. George's 'minumental' version, small enough to be pocketed).

below
Sutapa Biswas. *To Kill Two Birds With One Stone*, Plug In Gallery, Winnipeg, 1993.
Photo: Wayne Baerwaldt.
© Plug In Gallery, Winnipeg.

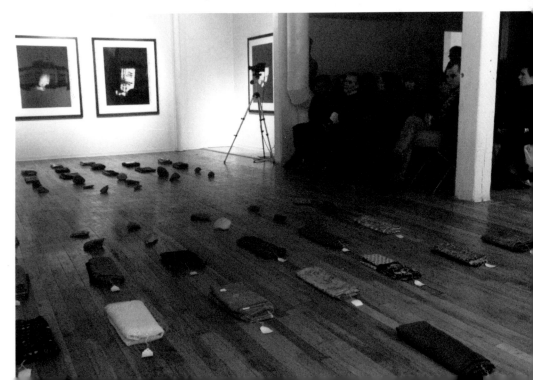

Given this, what does a particular spatial contextualisation of a work entail? Here the kind of work generally mounted by Locus+, that has so often concentrated on site-specific work and performance (the latter a non-repeatable conjunction of action, site and audience) is symptomatic. What is the meaning of the *locus solus*, the unique place or the solitary place or both, in which the art work dwells? And how does it change for different kinds of work? This is also a way of asking: what type of marginality are we dealing with in the curation and the display of work in a regional arts organisation that has no fixed space in which to show art? Can such an organisation be the neutral facilitator of artists' projects, free from mainstream concerns, as the organisers themselves claim?[16] There is an assumption in their statements that, left to themselves, artists will drift towards radical form and content, and that the demands of the mainstream institutions hold artists back from their natural instincts to subversion.

We should start with the particular spatial context in which Locus+ operates. It is certainly not confined to Newcastle or the Northeast of England, for the organisation makes a virtue of mobility. Nevertheless, if there is a continuity, it is found in the connection of regional cities—not capitals—of the north (and the West), in the exchange of works between, say, Derry, Hull, Belfast, Vancouver and Winnipeg. The attempt to establish, then, a network of artistic centres, that take a distance from the cosmopolitan global cities upon which the main attention of the art world is fixed, and between which works and people can be circulated.

The power of the global culture cities is immense: they have the advantages of a sufficient concentration of wealth, resources and people to create cultural fission, links with other such centres, and the allure that consequently hangs about their very names—London, Paris,

16 Bewley, Jon, and Simon Herbert, "Introduction", *Locus+, 1993-1996*, Samantha Wilkinson, ed., Newcastle upon Tyne: Locus+, 1996, p. 5.

below
Anya Gallaccio. *Two Sisters*, Minerva Pier, Kingston upon Hull, 1998.
Photo: Mike Sweeney.

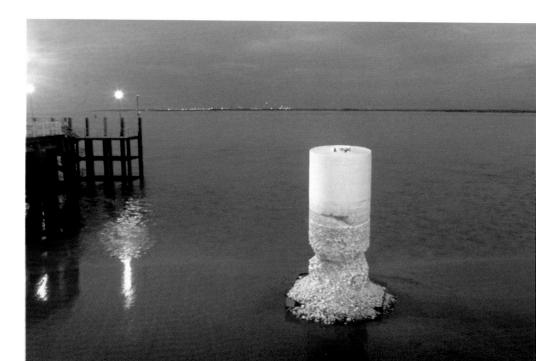

New York, Tokyo, Los Angeles. It is a concentration not only of the producers of art but also of its consumers—of people whose work involves some cultural component and who are very likely to go to galleries, buy art books or even limited edition prints and other serial productions, peruse art and style magazines. In Britain a third of all those engaged in cultural work are based in Greater London.[17]

17 Betterton, Rosemary, "The New British Art", Ferens Art Gallery, *History: The Mag Collection: Image-Based Art in Britain in the Late Twentieth Century*, Kingston upon Hull City Museums, Art Galleries and Archives, 1997, p. 129; her source is *Cultural Trends*, 1995.

Against this strong gravitational pull, it makes sense for regional arts organisations to establish their own network, a circuit of culture that holds itself aloof from the capitals, and also to support work that makes a virtue of its placement. The installation work of Anya Gallaccio, for example, tends to be temporary, non-replicable, unmoveable, unsaleable and site-specific. Such work sets up a number of barriers to circulation, both spatial and temporal. Although the work itself is temporary, its force is on the side of fixity, stasis and memory, its passing a pointed comment on the virtues of enduring. It asserts as a matter of principle that it is not a consumer object, to be bought, owned, moved about and sold. Sometimes, Gallaccio's creations cannot be moved without the destruction of their meaning: this was the case with *Two Sisters*, planted in the estuary at Hull in 1998. In Robert Irwin's typology of works that are put in a particular place, such a work falls into the category that is most under the sway of locality, being "site determined".[18] Furthermore, it cannot be permitted without supervision to pass through time, lest it eventually slip its leash and bound into undetermined meaning or commodification. Better that, having made its intervention, it is destroyed or is allowed to decay of its own accord. The appeal of such work for the regional arts organisation is obvious: to experience the work fully the viewer has no choice but to come to them; the work is never going to travel to you.

18 The other categories were 'site dominant', the other end of the scale in which a pre-existing piece is merely placed on a site, and the intermediate categories of 'site adjusted' and 'site specific'. Robert Irwin, "Being and Circumstance—Notes Towards a Confidential Art" (1985), in Stiles / Selz, *Documents*, pp. 573 and 574.

Such site-determined works, like performance works, are designed to be resistant, not just to the flux of market time, but also to the characteristics of the art and its engagement with viewers that flows from that abbreviated, hurried time. Their obdurate and often obscure being stands opposed to the exchange in swiftly recognisable symbols that passes for contemporary art in the salesrooms. Yet what the works purchase in profundity and quality of attention, they pay for with limited access, being available to a tiny, often elite, audience. This exclusivity raises once again the issue of memory and privilege, for if works of art gain through travel, or through the alteration of a particular site, and if it is of advantage to see these works first-hand, then (since travel is expensive) experience, memory and privilege are bound together in a finely graded hierarchy, dependent upon institutional power and wealth, and also often upon private means. The question has to be asked insistently: who is this art for? There is another price to be paid for integrity which the work of art purchases with its own swift death—in performance, enacted at the very moment the work is brought to life.

These works, though, do not entirely disappear with their own disappearance but have a long after-life in artificial memory: in archives and CVs, in photographs, compact discs, catalogues, postcards, posters, in monographs and other art books like this one. That after-life is often conceived as a part of artistic and curatorial work from the start. Many

artist-led and otherwise marginal organisations insist on the importance of documentation, visual and verbal, on the production of catalogues, brochures and websites, on the presence at the birth of the work of cameras and camcorders.

The results serve as aids to memory for those who were present, but what purpose do these often opaque documents fulfil for those who were not? Perhaps they act as fixed and insistent tokens of the works' resistance to reproducibility, the documents' very impoverishment being an assertion of the unique and authentic qualities of the work.

The documents are framed and reframed, as mental memories fade and time recedes, as temporal works are made thoroughly spatial. The mapping of a book like this, its disposition of reproductions and their relation to bodies of text (commissioned by Locus+), allow the retrospective making sense of a diverse body of work once scattered over time and space, and here brought together in a single, reproducible, moveable and saleable condensation. Again, such an object contains opposed forces, for its life seems at odds with the unique work, fixed in a solitary place and bounded strictly by time. The book, though a commodity, is rarely consumed by its owner but circulates unmolested, is resistant to flux, its time-capsule of thought fixed upon its pages.

Yet this fixing may itself be contradictory. In it, the work is reduced to a photograph and a concept, framed by a more or less pragmatic or poetic evocation of the work and its context, the summoning up of some political, social, aesthetic or intellectual context. The photograph is a ghostly rendition of the work, a skin peeled from its surface, in itself innocent of time, process or meaning. Then there is the bald concept which, as we have seen, can come to circulate in place of the work. Again Locus+ documentation can serve as a symptomatic example, though here there could be many thousands of others. Here is a short description of works from a Locus+ catalogue:

> A performance at the Plug In Gallery, Winnipeg, Canada, incorporating the use of twenty-nine saris borrowed from the local community. Accompanying soundtrack; artist's voice-over covering the history of the sari, the histories of the specific garments used in the performance and personal anecdotes. Performed 9th November 1992.[19]

19 Wilkinson, *Locus+*, p. 34. The work described is Sutapa Biswas' *To Kill Two Birds with One Stone.*

Combined with the photograph, such a description is a good instrumental tool, allowing the reverse-engineering of a similar work, or the commissioning of another work from the same artist by interested parties; or, with the aid of some conceptual context, it is sufficient for art critics and art historians to pronounce upon the work, or give them tools to pass comment on similar work. Essays like this one reframe works as museums and galleries do, by using more or less arbitrary juxtapositions of literary sources, political and social generalisations, in which the works sit, fragments of particularity bent to and embedded in the setting of the general.

Philip Napier. *Sovereign*,
Vancouver/Belfast, 1995.

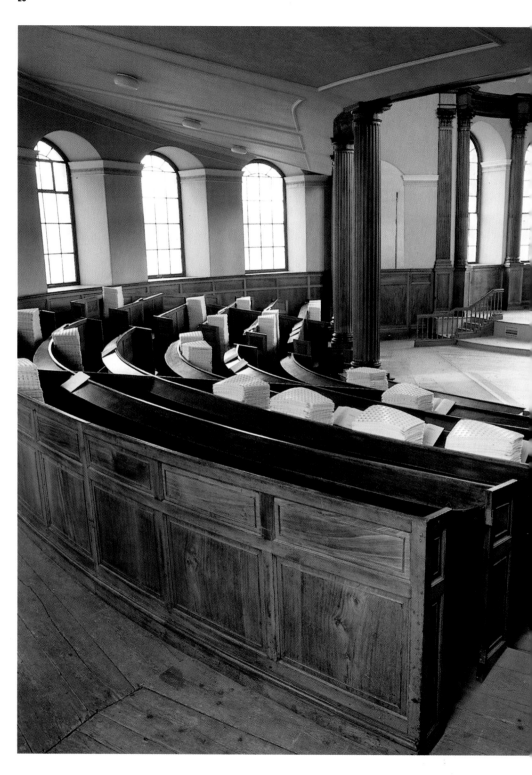

Perhaps, then, considered instrumentally and materially, these artificial memory devices retain not the husk but the core of the art work that cannot—except at the price of true invisibility and true extinction—resist all that follows from reproduction, from the dissemination of a host of flattened duplicates. Some site-specific works appear to make this fate a theme, as in John Newling's display in a church of the templates from which communion wafers are stamped out in a small-scale industrial process—the absent host being a literal sign of the absence of spirit. In the small-scale industry that is the production of art, an analysis of what is being produced and what consumed, and of the spatial and temporal determinants of those processes, could lead to a minor clearing of the mythological fog that surrounds these cultural commodities. For the time being, though, we are usually faced in books such as this with a parade of mechanical ghosts and their chorus of intellectual accompaniment.

Raymond Roussel, writing at the inception of mechanised warfare, and in the twilight out of which Dada and then Surrealism were to pitch their distinctive and radical voices, already warned of an art that was the product of death, a shell of its living self, either subject to the mechanical techniques of reproduction that could convincingly fake the most profound human creations, or (in imagined and bizarre technologies, magical in their utter rationality) that would conjure from the corpses of artists and poets meaningless snatches of their performances in life, much like a snatch of sound recording or video played over and over:

> [the subject] would at once reproduce, with strict exactitude, every slightest action performed by him during certain outstanding minutes of his life; then, without any break, he would indefinitely repeat the same unvarying series of deeds and gestures which he had chosen once and for all. The illusion of life was absolute: mobility of expression, the continual working of the lungs, speech, various action, walking—nothing was missing.[20]

20 Roussel, Raymond, *Locus Solus*, trans. Rupert Copeland Cuningham, London: John Calder, 1983 edition, p. 118.

Travel, taken in its broadest sense (the reframing that comes about through a change of context, intellectual or actual), the only whiff of Spring still open to the bourgeois mind enlivens work and viewers alike. It may, however, also serve to conceal exactly what it is that has been lost in the continual flux—of the change that comes to us even when we remain where we are—of economic time.

opposite
John Newling. *Skeleton*,
All Saints Church, Newcastle
upon Tyne, 1994.
Photo: Steve Collins.

THE RELATIVE SCALE OF THINGS

PAUL ST GEORGE AND MINUMENTAL SCULPTURE

DAVID MUSGRAVE

In the perception of relative size the human body enters into the continuum of sizes and establishes itself as a constant on that scale... The qualities of publicness or privateness are imposed on things. This is because of our experience in dealing with objects that move away from the constant of our own size in increasing or decreasing dimension... While specific size is a condition that structures one's response in terms of the more or less public or intimate, enormous objects in the class of monuments elicit a far more specific response to size qua size. That is, beside providing the condition for a set of responses, larger-sized objects exhibit size more specifically as an element.[1]

1 Morris, Robert, "Notes on Sculpture", reprinted in *Art in Theory 1900-1990*, Oxford: Blackwell,1997, p. 817.

Anyone who has walked through the centre of a modern city will be familiar with the feeling of scale elicited by twentieth century architecture, the sense of human beings reduced to replaceable cells in a durable machine. To stand beneath an office building six hundred feet high is also to recognise that that building is well over one hundred times the height of an average adult human, and immediately a power relationship has been established. This, at least, has not changed since 1966, when Robert Morris wrote the above words. Scale has an inbuilt rhetoric, and it operates in both directions. To give an inverse example, in Don DeLillo's novel *Underworld*, J Edgar Hoover is credited with a paranoid fixation on the presence of airborne germs, a fixation which stems from his apprehension of inhuman scale; being too small to see with the naked eye, Hoover's imagination involuntarily takes over, causing him to perceive the air in a baseball stadium as 'an all-pervading medium of pathogens, microbes, floating colonies of spirochetes that fuse and separate and elongate and spiral and engulf, whole trainloads of matter that people cough forth, rudimentary and deadly.'[2] Bringing a human being into the loop fills the abstract notion of scale with significance, and the presence of a human being is a precondition of any artwork.

2 DeLillo, Don, *Underworld*, London: Picador, 1998, pp. 18 and 19.

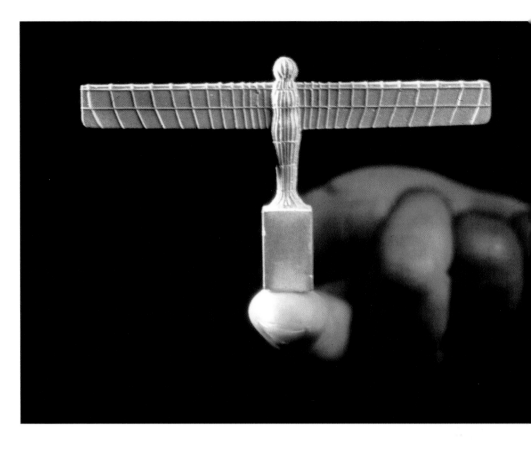

Very few visual artists of international repute use the second extreme of scale to great advantage in their work, while remarkably many use the former. The monumental work, the sculpture, painting, photograph or projection that engulfs the spectator in a powerful display of accomplishment, remains the generally accepted means of securing a reputation. Once a work exceeds the dimensions of the viewer it aspires to the condition of an environment, and as such attempts to dominate the viewer's perceptions entirely, albeit usually for a short period of time. The implicit display of mastery is the subject of Paul St George's gently ironic practice.

His project involves two distinct processes: the first is to select works of twentieth-century sculpture that he deems 'important'; the second is to reproduce those works to a standard size, each one able to fit within a cube 10.5cm x 10.5cm x 10.5cm. Punningly referring to their diminutive scale, the works are labelled 'Minumental' sculptures and are produced in editions of 250.

Not every artist uses scale in an authoritarian way (Mark Rothko famously argued that the vast proportions of his canvasses created a greater bodily intimacy with the viewer than smaller, less worldly works), but St George tends to select works by those who do. Antony

above
Paul St George. *Minumental Angel of the North*, 1998.
Photo: Andrew Putler
© Paul St George.

above
Paul St George. *Minumental House of Velti*, 1999.
photo: Peter White
© Paul St George

Gormley's *Angel of the North*, Britain's largest and most newsworthy piece of public sculpture since David Mach's incendiary submarine, has received the reductive treatment. All of the problematic associations with Fascist imagery that have generated controversy about the piece evaporate once the element of monumentality is removed, and *Minumental Angel of the North*, the domesticated offspring of Gormley's singular, commanding giant, has the character of decorative charm. St George has made a counter-claim against a Feng Shui expert's analysis of the pernicious effects of the original work, stating that in its Minumental form the *Angel of the North* can actually improve the spiritual dynamics of a room.[3] The comment is intended as light-hearted, but in this very intention the physical and ideological dangers of monumental sculpture are brought into focus.

3 See St George's letter in *Art Monthly* no. 217, June 1998, p. 15.

The scale of a monument is not merely a blunt physical fact but also an explicit validation of a particular world view, an expression of a mode of perception that has met the various bureaucratic criteria that any publicly presented object inevitably must; 'public art' is not, of course, a term that usually refers to art made by or even for the public, just art that happens to exist lawfully in a public space. At the opposite end of the spectrum we could place graffiti, whose presence is not condoned by bodies funded with public money and therefore has a short life-expectancy. Recent history has proven, however, that even

officially sanctioned expression can meet with successful resistance. The case of Richard Serra's *Tilted Arc* (remade by St George to an approximate scale of 1/3500) became a *cause célèbre* when office workers who used the courtyard in which it was installed complained that it had destroyed the sense of community enjoyed by those who congregated there for lunch. It is hard to think of a better example of contemporary art's agendas abutting against the practicalities of everyday existence. After a protracted court case, which finds its satirical double in William Gaddis' novel *A Frolic of His Own* (Serra's *Tilted Arc* becomes R Szyrk's *Cyclone Seven*, and the problem of segregation is transformed into the case of a trapped dog, but the positions articulated are uncannily similar), the wishes of those who used the space were respected and the sculpture was removed.[4] Many pertinent questions about the contract between artist and public were raised, questions which also preoccupy Paul St George. His *Minumental Tilted Arc* is unlikely to be regarded as a public nuisance, and also has the advantage that it is still in existence. In effect, the piece is a pathetic symbol of a cultural problem, a wry reflection on the social reception of art which identifies itself as advanced.

4 Gaddis, William, *A Frolic of His Own*, Harmondsworth: Penguin, 1995, particularly pp. 31-40 and 285-293. The events described by Gaddis take a rather more tragic turn than in the *Tilted Arc* case. Before the sculpture can be lawfully removed, *Cyclone Seven* is "struck by a bolt of lightening, and its reluctant tenant found to have been released forever from the travails of earthly existence". (p. 286)

The *Tilted Arc* case is explored in depth in Anna C Chave's article "Minimalism and the Rhetoric of Power", the text that sounds the theoretical keynote of St George's enterprise. Chave systematically problematises the assumptions of minimalist art, framing, if not exactly exposing, the physical and semantic brutalities doled out by its exponents. The language of space, presence and domination is shown to be a connecting factor not only between various pieces of work, but also the ways in which the artists have discussed it. Morris' text has a deadeningly prosaic, almost mantric tone that beats home the principles that determine our ordinary bodily relationship with the world; in this respect it amply mirrors at least part of what minimalist art hoped to achieve. He provides an outline of not only his conception of the place of sculpture in the world of objects, but also a general theory of the relation of objects to people who experience them. This perspective places sculpture in the same material world as office buildings, missile silos, ballpoint pens and motor vehicles,

left to right
Paul St George.
Minumental Ghost, 1996.
Minumental Impossibility, 1996.
Minumental Tilted Arc, 1996.
Minumental Wrapped Reichstag, 1996.
Photos: Peter White
© Paul St George.

an association which is more complex and problematic than it might seem. For Morris and Serra at least, the recognition of this parity of art objects with the elements of post-industrial life led to work which was often deliberately intimidating.

The recrudescence of the minimalist aesthetic over the last ten years in the work of, for example, Julian Opie, Damien Hirst and Rachael Whiteread, to stick to artists who have been minumentalised, clearly point up the social and political shifts that have occurred in the intervening period. While Chave can comfortably cross-reference the brutalities of US foreign and domestic policy in the 60s and 70s with the works produced by American artists prominent at the time, ultimately she concludes that the position they articulate is one of carefully gauged silence, "a kind of connoisseurship of non-commitment."[5] She goes on to argue that this in itself constitutes a political statement of sorts, one that plays out Adorno's conception of a technologically threatened subject who "raises its disenfranchisement to the level of consciousness, one might almost say to the level of a programme for artistic production."[6]

5 Anna C Chave, "Minimalism and the Rhetoric of Power", *Arts Magazine*, vol. 64, no. 5, January 1990, pp. 44- 63, quoting in this instance Brian O'Doherty on the minimalists in 1966.

6 Chave, "Minimalism", quoting Theodor Adorno, *Aesthetic Theory*, London: Routledge, 1984, p. 35.

Chave is able to sustain this argument in relation to Judd, Andre, Morris et al in a way that seem totally irrelevant to those who have recently adopted elements of the minimalist idiom. Hirst's work is titled in such a way as to prioritise individual and often intimately private experience over a broadly political one; Whiteread, too, despite infrequent and perfunctory references to the Thatcherite climate in which her generation thrived, invariably emphasises the relationship of her work to personal memories; Julian Opie is perhaps the only artist of these three who strives for genuine impersonality, but he does so in a way that suggests a potential responsiveness to the individual viewer—his titles are porous and inviting, offering suggestions to the viewer (*Imagine you can order these, Imagine you are driving*) for the mental manipulation of the otherwise mutely geometric work.

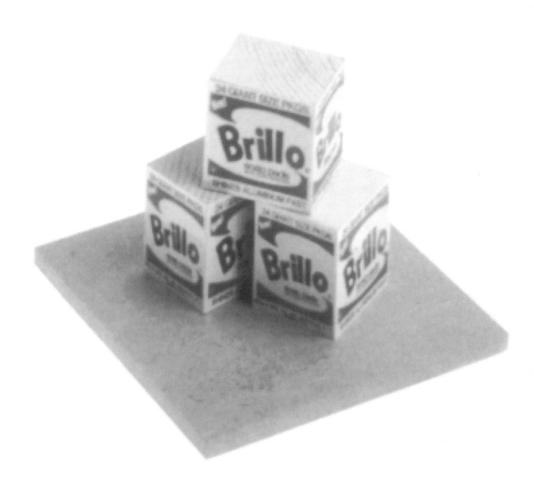

St George provides a meta narrative of such shifts through his editing process, offering a god's eye view without, however, making any grandiose claims for himself. He is at once engaged and detached, the former in the sense in which a craftsman is intimately involved with his processes, and the latter in that those processes are determined by a contemplative selection. The story elaborated above is, of course, only one of the possible routes it is possible to trace through the Minumentals. One might just as easily link, for instance, Meret Oppenheim, Richard Artschwager and Jeff Koons for their referencing of domestic and consumer goods in the century's art, or Joseph Beuys, Damien Hirst and Anya Gallaccio for their use of ephemeral, organic materials.

Paul St George. *Minumental Brillo Boxes*, 1996.
Photo: Peter White
© Paul St George.

As a whole Minumental Sculptures will, St George claims, provide a "comprehensive summary of 20th Century sculpture", but this statement in itself means that the value of his selections is disputable. He might justly be accused of parochialism in his selections, since British artists who have come to prominence in the last ten years currently account for a high percentage of the selections, while not having had the time to secure anything like the kind of critical validation possessed by, say, Andy Warhol or Richard Long. A viewer of the project as a whole would have to conclude that this is part of the point: that is, the creation of a zone where it might be possible to think about exactly how Dan Graham measures up to Joseph Beuys, or Kerry Stuart to Phillip King. Their juxtapositions may be arbitrary or illuminating, articulate or inert.

The project might seem academic were it not for the fact that the commentary on offer is essentially a silent and ambiguous one: manufacturing Marcel Duchamp's *Bottle Rack* in metal at a fraction of the scale of the original item clearly means something different to making and wrapping a miniature Reichstag. These tiny objects elaborate a subjective history of twentieth-century art, and quietly embrace the fact that the privilege of 'importance' is awarded arbitrarily by those who view and think about art. The importance of Duchamp's *Bottle Rack* is of an altogether different order to that of Christo's *Wrapped Reichstag* (the first contributed to the extension of artistic practice into the realms of language, the second is a singular and, for all its political reverberations, primarily physical gesture), and the fact that St George has made them both testifies only to his own recognition of their significance. They cannot be made to fit the same scale in any but the most literal sense.

The importance of a multiplicity of possible readings and routes through the work is accentuated by the fact that Minumental Sculptures exist in large editions. Despite the recent perceived increase in the accessibility of modern and contemporary art, the collection of most major works remains the preserve of a tiny, wealthy few. St George's stated egalitarian intention is to bring contemporary sculpture and its attendant debates within the reach of as many people as possible. We can choose whether or not to take him at his word. There is an element of knowingness to the Minumental sculpture series that is at odds with this altruistic sentiment. Without already being involved with the whole perplexing business of contemporary sculpture and its viewing, they might remain a peculiar and irrational sequence of objects. But then perhaps, contradictorily, an involvement with twentieth-century sculpture only makes the series even more puzzling. St George records all the conflicts, reversals, ambiguities and misreadings that run like fault lines through the art of the last hundred years, reflecting a wildly heterogeneous body of work which is impossible to consolidate since it shares no common factor other than the one arbitrarily imposed by St George. In a sense what we are left with is the opposite of a history. Here is a group of objects inviting configuration by the viewer, replicated evidence in a case that remains open.

SEARCH

PAT NALDI &
WENDY KIRKUP

HELEN
CADWALLADER

Search was developed by Pat Naldi and Wendy Kirkup from the knowledge that the Northumbria Police service, working with Newcastle City Council, had recently installed a surveillance system in the commercial centre of Newcastle in 1993. The result is an eight-minute video documenting a synchronised walk or 'enactment' undertaken by the artists throughout the city.

The surveillance system, implemented primarily in response to local business demands for greater security measures, consists of sixteen black and white cameras feeding four monitors in a centrally located control room operated by the police service. As such the system is designed to monitor and document criminal activity and 'civil disturbances' in the city centre.

This modern surveillance system, embedded in the architectural structure of the city, echoes the principles of Jeremy Bentham's eighteenth-century panopticon or Inspection House. Designed for use primarily as a penal institution, the panopticon was a circular building with cells at the periphery and a central viewing tower from which a superintendent could keep the establishment under surveillance. For the French theorist Michel Foucault, such a design marked a significant event in the history of the human mind by legitimising and institutionalising the dissemination of power and control through surveillance.[1] Whilst the principles underpinning the design are the same, the technologically mediated surveillance system goes beyond the physical constraints of architecture by dispersing power and control across the 'body' of the city, predicated as this is through the 'look' or 'gaze'. This is achieved through images being viewed or recorded using either real-time or time-lapse options and the siting of cameras at key vantage points throughout the city centre. As the artists themselves put it, this results in a continuity of knowledge being mapped out at any one time across a wide geographic space.

1 Foucault, Michel, *Discipline and Punish*, Harmondsworth: Penguin, 1979.

The activity of viewing and processing information, gathered through visual surveillance, can be characterised as a dichotomy between an active spectating subject and the object of this inquisitive gaze that (or who) is at once both passive and relegated to an inferior position through this unequal distribution and acquisition of 'knowledge' which privileges the spectator.

Such a duality is played out in complex ways, not least through the formal syntax of the visual code but also through the process and moment of viewing. As spectators we participate in this contract of complicity and collusion staged through much of the *Search* video enactment. Indeed, the very title itself invites us, as spectators, to stake out a superior position of active knowledge acquisition. To search: to look through or overly carefully or thoroughly in order to discover something. Again this is worked out with heavy irony through the video scenario of the detective-based narrative. We see a 'character' (one of the artists) donning a trench coat, the archetypal detective uniform, in order to 'search' for clues. As viewers, our desire to 'know' is literally played out through the 'detective' who is apparently in pursuit of an assailant or seeking a rendezvous with a shadowy accomplice. This 'chase' is observed and recorded through the surveillance system which is, in turn, one of the very real means by which the police themselves gather information.

But our desire for visual clues with which to complete the 'picture'—partly promised through the omniscient authority of the surveillance technology—is denied in a number of ways. Firstly the option, made by the artists, to use time-lapse imagery means that certain images are chosen and others excluded to produce an incomplete picture of both the city and the video enactment. As a result, there are glaring omissions in our visual knowledge. Temporal as opposed to spatial continuity is, therefore, privileged in linking together wide-angle shots of the city centre with its corporate architecture and bustling crowds alongside middle-distance shots focusing on the movements of the two artists. Furthermore, as spectators, certain expectations are established through the codes and conventions drawn from the classic detective thriller format. These centre on a narrative orientated around the investigations and activities of a male protagonist and which relegates female characters to a passive role either as victim or as an object of erotic contemplation. This former assumption, of the proactive and therefore male detective, echoes the reality of a police service which sees a disproportionate number of male officers promoted to the status of detective. Given this, our expectations, then, are radically reversed in the closing sequences of the video enactment when the 'true' identity of the two protagonists are very deliberately foregrounded—as women. This moment is marked when the two artists turn to gaze directly into the (two separate) camera(s) which also signals the 'closure' of the video enactment as the time codes are finally eradicated from the video frame. Our former status as spectators in privileged positions of knowledge—achieved through the 'look', and the spectatorial omniscience of the surveillance system coupled with the assumptions generated through the generic codes and conventions—are radically challenged and undermined. Through the evocation of a narrative

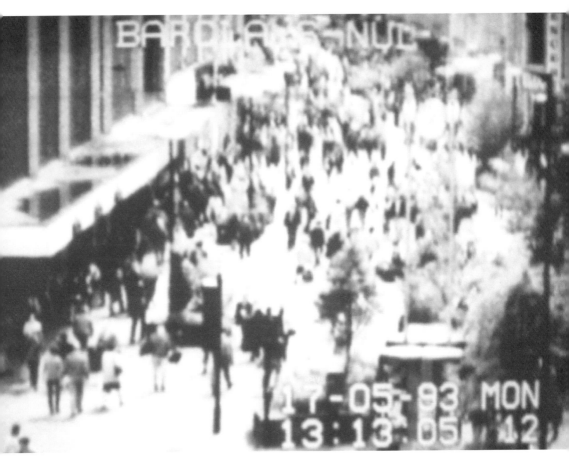

2 Mulvey, Laura, "Visual
Pleasure and Narrative
Cinema", Screen, 16, no. 3,
Autumn 1975.

above
Pat Naldi and Wendy Kirkup.
Search, surveillance still,
Newcastle upon Tyne
city centre, 1993.

scenario based on paranoia and voyeurism, which in turn are the main
characteristics of any surveillance system (both real and conceptual),
our gaze as a spectator is returned by the female gaze forcing us to ask
the questions: Who is watching who? Who is the subject now?

The implications of this act of defiance are multi-fold. Not least in terms
of challenging the ideological values written into the viewing experience,
between the viewing subject and—in this instance—the video enactment
along with the viewing apparatus (surveillance system). Classic feminist
cultural theory has critiqued the institutions, specific fantasy scenarios
and the viewing structures underpinning and written into much art
history and popular cultural formats such as film which, it is argued, are
designed to promote and privilege both the status and desires of (white,
heterosexual) men. [2] For example, one such point of contention argues
that many popular film products construct spectating positions and the
narrative fantasy scenarios whereby women become the objects of
sexually orientated male visual pleasures. Such observations raise very
serious questions concerning not only mainstream culture, but the
supporting visual apparatus (in this instance, surveillance systems), as a
technology not only of control and discipline, but also of male power. But

these early feminist critiques were flawed by implying both an essentialist sexual politic and advocating the determinist and therefore non-negotiable operation of any visual apparatus (the cinema, etc.). This effectively foreclosed the opportunity for women to work with processes emphasising the 'look' and thereby the possibility to devise different forms of visual pleasure. Naldi and Kirkup have chosen to directly engage with such issues by intervening with certain visual technologies: a closed-circuit television surveillance system as a means to construct a different space from which to articulate an alternative and previously unheard voice.

In addition, the surveillance system can quite reasonably be dubbed a technology of 'male' power, not least because it is operated by a public service institution renowned for privileging male officers and for servicing the interests of corporate business. Furthermore, as part of the fabric of the city centre, this is a public space given over—not only to 'work'—but to a visible demonstration of corporate and civic power which further consolidates this inscription of patrician authority.

Given these characteristics governing the physical setting—the visual operation of the video enactment and the emphasis upon the inquisitional 'look' (all part of the visual apparatus of the surveillance system)—it is quite fitting that *Search* was 'sited' on television. Put

above
Pat Naldi and Wendy Kirkup.
Search, surveillance still,
Newcastle upon Tyne
city centre, 1993.

simply, TV is not only a visual technology but, like the city, operates a 'public' space which is ideologically complicit, its ubiquitous nature, as a cultural format and as a physical unit, disguising its exclusivity in terms of real cultural access and again its dependency upon the market-place and private capital—both as a physical unit and in terms of the network's dependence on advertising. It was as part of this latter 'space' that *Search* was broadcast. As grainy black and white, short, silent sequences segued into the flow of glossy, full colour highly conventionalised, yet seductive , mini-dramas centring on lifestyles. The *Search* 'episodes' effectively disrupted the flow of these impossible dream-like spectacles. On one occasion, *Search* struck a freakish note of discord squeezed, as it was, between commercials for hair colorants and baby food during the advertising break of that off-peak, yet hugely popular, day-time viewing favourite *This Morning*. Less bizarre alliances were made when, as was the more common tendency, *Search* was scheduled at the end of the police-based drama series *The Bill* and alongside *Crimestoppers* (the Public Service Announcements detailing criminal incidents such as theft, and which often feature the same awkward, grainy, black and white video images culled from closed-circuit television surveillance systems). The *Search* episodes, then, functioned as an interventionist strategy akin to some pirate TV transmission in both appearance and enigmatic effect. Although, paradoxically, in order to be realised the project quite literally 'bought into' these advertising slots.

Through *Search*, Pat Naldi and Wendy Kirkup have demonstrated and articulated two features predominant in contemporary culture, namely paranoia and voyeurism, in which certain technologies of (male) power become part of the ideological social totality, which as Foucault has argued, we have created for ourselves.

above
Pat Naldi and Wendy Kirkup.
Search, survellance stills,
Adelaide, 1996.

IDENTITY

PARKING IN
ALLEYWAYS
IS
PROHIBITED

SEEKING REDRESS:

IDENTITY AND

THE VISUAL ARTS

NIRU RATNAM

Late summer 1994 was one of those moments in the recent history of the Irish troubles when peace seemed like a realistic prospect. By coincidence, in Belfast, a city divided by the legacy of British imperialism, a mural went up for one week in a disused mill. The creator of the mural was Nhan Duc Nguyen, an artist born in South Vietnam to a Vietnamese father and a Phillipina mother. Airlifted out before the fall of Saigon, Nguyen lived in the Philippines for ten years before he and his family resettled in Canada.

Prior to leaving for Canada, Nguyen got to participate in a North American's imagined reconstruction of his native country's recent history. He acted as an extra in Francis Ford Coppola's *Apocalypse Now*, thereby playing out part of his cultural identity which he had never actually lived. In Northern Ireland, Nguyen restaged his own version of his remembered and imagined life, from the traumas of childhood through recent events in Canada to an imagined future and end. Nguyen's work was a meditation on what the two sides in Northern Ireland had been fighting over for years; belonging, subjectivity, nationhood, roots. In short, a sense of identity.

The past thirty years has seen an explosion in the study of identity within a variety of subject areas, although as Paul Gilroy notes, the concept of identity has long been of concern in social thought.[1] Gilroy persuasively argues that contemporary interest in identity stems from its ability to link the scholarly and the political. Furthermore he sees the interest in 'cultural identity' as indicative of the increased attention given to the relationship between culture and power. Others argue that the focus on identity has gone too far, reducing whole fields such as cultural studies to the question of identity. That this idea should be considered at all is testament to the proliferation of writing about identity in recent years, so it is worthwhile remembering that this range of positions has only opened up relatively recently. Previously, theories of identity almost always hinged around the existence of some irreducible internal core in each of us which would implacably determine where and with whom we belonged. Clifford Geertz, writing in 1963 about ethnic identity, famously terms these internal drives "primordial attachments" and argues that they were natural ("some would say spiritual..."), a priori, and inescapable. Critics of the primordialist position point instead to the social construction of identity. Apriority, the cornerstone of primordialist positions, ignores the functions of the family and state apparatuses in moulding subjectivity and instilling a sense of belonging. For example, Simone de Beauvoir argues in The Second Sex that "one is not born a woman, but, rather, becomes one" so that for her, the identity of "female" is a constructed, rather than an a priori one.[2]

Theories which dispute the primordialist position are sometimes termed instrumentalist or constructionalist, because they stress the invented and imagined nature of social identity. John Comaroff identifies four categories of constructionist theories. The 'realist perspective' is based on the existence of objective interests behind the development of a collective identity, but often fails to explain why social identity should be based on cultural attachments in the first place. 'Cultural constructionism' depends on group identity arising from a shared set of symbols and signifying practices, but questions of power and materiality are left untouched. 'Political constructionism' focuses on the way elites of a group fashion social knowledge and then impose this within a group through hegemony. 'Radical historicism' regards social identities as the result of long-term processes, where the collective consciousness is the result of material inequalities being inscribed through cultural differences.[3] If one additionally takes into account the discourses of poststructuralism and psychoanalysis which question the very ideas of self and subjectivity, it becomes apparent that identity has become a very cluttered and contested term. This rise in interest around identity might seem somewhat surprising given that it comes so soon after poststructuralism had proclaimed the death of the subject, but as Ernesto Laclau points out, perhaps it was precisely this death of the subject, which allows a renewed interest in subjectivity.[4]

The growth of interest in identity in theory, and especially the notion that the self was not only historically constructed but the subject of regulatory discourses has been reflected in the visual arts. Identity became the key focus for feminist artists in 70s North America, spurred on by the continual gender imbalance in museum shows of

1 Gilroy, Paul, "British Cultural Studies and the Pitfalls of Identity", Black British Cultural Studies, H. Baker, M. Diawara and R. Lindeborg eds., Chicago: University of Chicago Press, 1996, p. 224.

2 de Beauvoir, Simone, The Second Sex, New York: Vintage, 1973, p. 301.

3 Comaroff, John L, "Ethnicity, Nationalism and the Politics of Difference in an Age of Revolution", The Politics of Difference, Edwin Wilmsen and Patrick McAllister eds., Chicago: University of Chicago Press,1996, pp. 165 and 166.

4 Laclau, Ernesto "Universalism, Particularism, and the Question of Identity", Politics, Wilmsen and McAllister eds., p. 116.

contemporary art. Artists such as Faith Wilding, Hannah Wilke and Carolee Schneemann (who acknowledged de Beauvoir's *The Second Sex* as an influence) all made work exploring female identity, although as many have pointed out, much of the work was rooted in a return of essentialism, albeit this time a primordial women's identity. As Daniel Bell suggested in the 70s, essentialism here did not have the same role as it did in say, patriarchal or racist discourses, but rather was a strategic move by previously disadvantaged groups "as a new way of seeking political redress in the society".[5]

5 Bell, Daniel, "Ethnicity and Social Change", *Ethnicity: Theory and Experience*, Hutchinson and Smith eds., Oxford: Oxford University Press, 1975, p. 144.

6 Sandler, Irving, *Art of the Postmodern Era*, New York: HarperCollins, 1996, p. 124.

Performance art played a key role in first-generation feminism as Irving Sandler has noted.[6] Influenced by the work of Bruce Nauman and Vito Acconci, feminist performance artists valued the immediacy of the audience and the stress on autobiography and narrative that performance allowed. In Britain, it was precisely these attributes which were at work in one of the first works to address ethnic identity, Rasheed Araeen's *"Paki Bastard". Portrait of the Artist as a Black Person*, first performed in 1977 with Araeen sitting, blind and gagged, whilst fifty images, some of which were autobiographical, flashed up behind him. Araeen's work stands at the beginning of a surge in British art concerned with cultural identity, which drew upon the legacy of the Black civil rights movement as well as the strategies of feminist art. However, like feminist art in America, and American art which addressed cultural identity (for example the work of David Hammons and Adrian Piper), British 'Black' art soon found itself tolerated by the mainstream as long as it was confined to a pigeonhole. Contemporary investigations into identity in the visual arts have had to be aware of sliding into the fixed positions which institutions and curators like to see. As we shall see, this has meant negotiating identity on three levels; the level of the self, the level of the other and the level of regulatory discursive practices. Performance and time-based art with their stress on the momentary and the contingent have proved to be remarkably relevant and appropriate to this set of careful negotiations. So it is entirely fitting that the diverse artists' projects carried out with Locus+ over the past years be used to attempt to articulate the enduring importance of identity to the visual arts.

SELF-FASHIONING

Imagine seeing the story of your life which you had never been able to see completely before. You had seen bits—a fragment here, another tableau there, but never all of it, yet suddenly, momentarily, it was here, shimmering in front of you. Of course, this is a fantasy, for one can never grasp the whole in its entirety, one can never stand back and say, yes, that was me, that is me, that will be me. Unlike Scrooge, we do not have an accommodating ghost to take us on a time-travel through our own lives, and so our sense of self is made up from memory and projection, the one fading, the other fictive. In this sense, our identities become as much about self-fashioning as anything else.

As a child, Nhan Nguyen had acted in someone else's reconstruction of "his" life; in Belfast he got to do his own act of self-construction. *Temple of My Familiar* consisted of seventy panels making up a large mural, and

was sited in a disused mill just off the Falls Road in Belfast. Big, Eastern looking figures were mixed with abstract swirls of colour, forming a set of composite images which drew upon Vietnamese social and religious life as well as anecdotal material. Nguyen had never seen the piece in its entirety beforehand, having made each panel on his kitchen table in Canada (hence their size). Nguyen stated that the images in the piece had come to him during a temporary period of blindness, the result of being set upon in the restaurant where he worked. That these images came to Nguyen in a heightened state of imagination is particularly apt, for if one's identity can no longer be guaranteed by family, nation, class, race or gender, then an imagined reconstruction and positioning of the self becomes necessary. Like another artist who has worked with Locus+, Stefan Gec, Nguyen has to an extent self-fashioned his identity. Prior to 1996 Gec had never been to the Ukraine, where his father was from, but his work repeatedly explores the legacy of the Ukraine in his sense of self. Similarly Nguyen's mural insistently referred to Vietnam which he had left as a child. Some of the references such as dragons and serpents were more fabulous than others, reminding us that this was as much an imagined homeland as a real one.

The dismantling of primordialism suggested that identity might be as much voluntaristic as given. A myriad of subject positions could be open to the individual—after all, if there was nothing inside us to tell us who we were, then perhaps we could make it up as we went along. At its extreme, this notion of 'conveyor-belt identity' (as it has sometimes

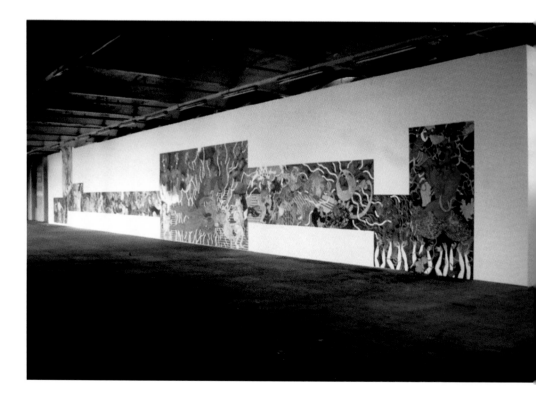

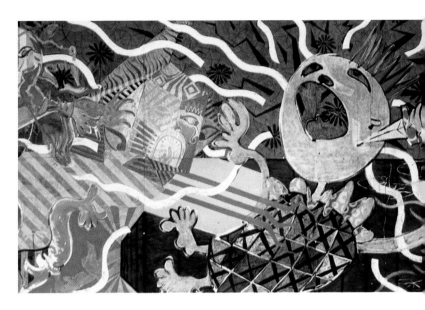

opposite
Nhan Nguyen. *The Temple of My Familiar*, Blackstaff Mill, Falls Road, Belfast, 1994.
Photo: Jon Bewley.

above
Nhan Nguyen. *The Temple of My Familiar* (detail).
Photo: Jon Bewley.

been referred to) envisioned a scenario of subjects picking and choosing positions at will. The major problem with this somewhat naive scenario, is the assumption that a unified, sovereign self is able to stand above jostling identities before picking one out. Not only is this untenable, particularly in light of poststructuralist and psychoanalytic theory, but it is a scenario which slips primordialism in through the back door, for the idea that one can choose identity by wish implies that these identities are masks hiding the true self. The simple act of 'choosing' one identity necessitates excluding others, and in so doing the field of difference opens up. Like language, any identity is defined in relation to what it is not, and so subject positions whether they be female, white, black or Arsenal supporter all are dependent on the play of difference. Additionally, taking poststructuralism on board necessitates the acceptance that all acts of signification (for example, culture) can never be full unto themselves for the signifier can never correspond exactly to the signified. Production of the self can never result in a stable, unified identity, but is, at best a contingent moment of closure—hitting the pause button on the constant, ongoing process of working with and through difference.

We can thus see Nguyen's mural as a moment of closure. That he had never seen the work as a whole before is apt, for it meant that its actual installation provided a very tangible moment of a contingent full-stop. The form that the work took, that of a temporary installation, heightened the feeling of this being a provisional moment. It is similarly apt that a catalogue essay detailing Gec's exploration of his Ukranian identify begins, "Stefan Gec lives in a flat in Mission Place, in Peckham".[7] Gec's visit to the Ukraine, of which he wrote in his diary "I had finally arrived", is no more than an arbitrary closure—his arrival is not final, and the essayist will ultimately locate him in the less romantic environs of South London. The sense of sadness which permeates much of his work, from the subject matter (firemen who died in Chernobyl) to materials (bells

7 Hilty, Greg "*Homing*", in Stefan Gec, *Trace Elements*, Newcastle upon Tyne: Locus+, 1995, p. 4.

cast from decommissioned Soviet submarines) perhaps result from a recognition that this quest for a definite identity is a hopeless one. Nguyen's work, in contrast, seems to blaze with the joy of finally being able to express subjecthood. As a temporary gesture, it contrasted with the legacy of political murals of Belfast, and perhaps offered a vision of identity which, in its fleetingness, could not be reduced to the rhetoric of blood and soil.

THE ROLE OF THE OTHER

Any investigation into subjectivity or identity at some point has to take into consideration that neither is formed in a vacuum. "The Fact of Blackness", the remarkable, rhetorical central chapter in Frantz Fanon's *Black Skin White Masks* is a series of responses to the cry of a white child, who on encountering Fanon in a street, cries to its mother, "Look, a Negro!". The chapter attempts to make sense of Fanon's discovery that his 'blackness' is constituted by a white other, and in relation to a white other. It is no coincidence that this seminal text should come from the discourse of psychoanalysis. It is that discipline (although Hegel and Sartre are also important references) which has proved the richest source for contemporary theory on how the self is formed. In particular, the work of Jacques Lacan about the figure of the "Other" in the constitution of subjectivity has been of particular importance.[8] Lacan draws on Hegel to posit a scenario where the self is constituted not only for the Other, but by the Other in an endless play of gaze and counter-gaze:

> For in this labour which he undertakes to reconstruct *for another*, he rediscovers the fundamental alienation that made him construct it *like another*, and which has always destined it to be taken from him *by another*[9]

Both feminist and postcolonial theorists have drawn upon this account to articulate the formation of the sexed and raced subject in an unequal dialectical relationship with a patriarchal and white self who designates the sexed and raced subject as Other.[10] In the practice of the visual arts, artists have used various strategies both in order to reflect upon this Lacanian construction of the subject, and to contest the unequal relationship between self and Other. The American artist Adrian Piper's *My Calling Card* started with the simple statement, "I am black", typifying the reclamation of a previously subordinate identity. This was a move which characterised 80s identity politics, a strategy also seen in the reclamation of "queer" as a positive term.

Where 70s and 80s visual art attempted to reverse the unequal relationship between self and Other, contemporary art has attempted to deal with Lacan's more profound idea that the self is always inhabited by the Other. The Locus+ project by Lawrence Yuxweluptun, *An Indian Act Shooting the Indian Act*' typified this contemporary attempt to explore the unavoidable presence of Otherness in negotiating identity. Both performances of *An Indian Act Shooting the Indian Act* took place in England, where the Indian Act of the title was formulated. Still operational in Canada, the Indian Act dictates special conditions for

8 Lacan distinguishes between the other which is the imaginary counterpart that alienated the subject, and the Other which is beyond the language of the ego' and this unconscious is the discourse of the Other. Lacan's use of the Other is not straightforeard: sometimes he uses it to refer to one part of the Self-Other pair, at other times he uses it to refer to the whole field of alterity in which all subjects find themselves in.

9 Jacques Lacan, *Écrits: A Selection*, Alan Sheridan, trans. London: Routledge, 1987, p. 42.

10 It must be noted that a number of both feminist and postcolonial critics have argued against using Lacan, most notably Luce Irigary.

above
Lawrence Paul Yuxweluptun.
An Indian Act Shooting The
Indian Act, Healey Estate,
Northumberland, 1997.
Photo: Jon Bewley.

First Natives within the legal system and thereby is central to both land-claims and self-rule claims. In native dress, Yuxweluptun burned traditional herbs to consecrate the sites, played the Canadian and British national anthems through a ghetto blaster, and then shot at copies of the Indian Act. In its playfulness and literalness the piece harked back to conceptual art and early performance art, more of a political provocation in the spirit of European happenings than anything overtly concerned with identity or subjectivity. However, the context of the performances gave them extra resonance, the first taking place at Bisley shooting range, the second at the private estate at Healey in Northumberland. At the latter site, Yuxweluptun had to be handed the shotgun by the estate's owner as he was the only one with the legal right to load them. This act of physically handing the shotgun to Yuxweluptun and thereby legitimating his performance, can be read in terms of acknowledging the nature of Otherness. As the colonised Other, Yuxweluptun's act of shooting was dependent on the goodwill gesture of the colonial self. But read the other way around, the granting of permission to the colonised Other by the colonial self can be seen as an admission of the crucial but hidden role Empire played in consolidating the wealth of the English landed aristocracy as exemplified by Healey Estate. This relationship has been characterised by its secrecy; for example, Edward Said has provided a compelling account of how Sir Thomas Bertram's wealth in Jane Austen's Mansfield Part is dependent on colonialism and how the novel represses this.[11] The crucial

11 Said, Edward, Culture and Imperialism, New York: Vintage, 1992, pp. 110 and 111.

recognition in Said's reading, and the act of handing the gun to Yuxweluptun, is that the Other is not external, but rather both internal and constitutive of the self. The actual shooting parodied a history of displaying the Other, reaching back at least as far as Buffalo Bill's shows. The layering of the performance can be seen somewhat like this: the colonised Other shooting the act designed by the colonial self to control the Other, through permission of the self, whose permission acknowledges the constitutive role of the Other in the self, all in a parody of age-old surveillance of and display of the Other by the self. And, of course, there is no closure, for the shooting itself could not end the ongoing power wielded by the act.

Commenting on Fanon, Homi Bhabha describes the figure of the self as not opposed to its Other, but *tethered* to its "shadowy Other". Bhabha makes clear what was once expected of the subordinated (whether through race or gender) Other: "the Other should authorize the self, recognise its priority, fulfil its outlines, replete, indeed repeat, its references and still its fractured gaze."[12] Yet because the Other is not only tethered to the self, but following Lacan, internal to the self, the two are in a continual process of displacement, substitution and projection. Neither the position of the self, personified in the white male, colonial master and the Other, personified in either the radical separatist feminist or pan-Africanist, are stable, unified positions. Each position is irrevocably split by its Other. This recognition was vital in moving identity-politics away from both radical separatism, as well as the facile multiculturalist notion of the melting-pot, an idea that became irrelevant as it became clear that we were all quite mixed-up internally as it was. Nevertheless critics of theories which concentrated on the folding and overlapping between self and Other argued that too often the material reality which shaped our lives was being ignored in these accounts.[13] A consideration of context, and more specifically the powers of regulatory discursive practices, was thus also necessary in order to be able to explore identity and subjectivity fully.

12 Bhabha, Homi, *The Location of Culture*, London: Routledge, 1992, p. 98.

13 See, for example, Benita Parry, "Problems in Current Discourse Theory", *Oxford Literary Review* 9, pp. 27-58.

BETWEEN PERFORMANCE AND PEDAGOGY

One of the images in Nguyen's *Temple of My Familiar* was that of a Vietnamese artefact. The viewer may have supposed that this was a reference to the artist's cultural identity, another element in his act of self-remembering and self-fashioning. In fact, although the artefact originated in his village, Nguyen came across it in a French museum. If we also recall Nguyen's role as an extra in *Apocalypse Now*, we can begin to conceive of the third component in the formation of identity, that of being already spoken for. In both these cases, Nguyen's memories are determined by French and American versions of what it means to be Vietnamese.

Similarly, in "The Fact of Blackness" Fanon's realisation that his subjectivity is constituted as Other to the white self is quickly followed by the realisation that his subjectivity is also constituted in relation to an existing register of knowledge. In this sense what he is, has already been determined:

I discovered my blackness, my ethnic characteristics; and I was battered down by tom-toms, cannibalism, intellectual deficiency, fetishism, racial defects, slave-ships, and above all else, above all: "Sho' good eatin".[14]

14 Fanon, Frantz, *Black Skin, White Masks*, MacGibbon and Kee, 1986, p. 112.

Fanon finds that his subject-position has already been constituted, a position which is at the opposite end of the spectrum from the notion of self-fashioning.

In his seminal essay, "Ideology and Ideological State Apparatuses" (ISAs), Louis Althusser makes a comparable arguement with respect to the construction of the subject in general. For Althusser, the individual only comes to subjecthood when she is hailed by discourse, an act which Althusser compares to hearing someone cry in the street, "Hey, you there". He terms this process "interpellation", where ideology literally "recruits" subjects. The subject's recognition that it is she who has been hailed is the key moment for Althusser. For by comparing interpellation to being hailed in the street, Althusser is attempting to suggest that the subject comes to a belated recognition that she is always-already a subject. The moment of being hailed is always a past one, "Ideology has always-already interpellated individuals as subjects".[15] There is no prior space where one is an individual, rather than a hailed subject, although Althusser seems to suggest that the idea of the non-subjected individual must be kept as an abstraction. To support this idea, Althusser recalls Freud's observation that even at birth, one is subjected to the ideological apparatuses which surround a human birth. Althusser's argument draws heavily on Lacan's notion of the mirror stage, where identity comes from the specular recognition of the self in the metaphorical mirror (which is a misrecognition—*méconnaissance*), and indeed one of the reasons why the ISAs essay is seminal is this attempt to think together the discourses of Marxism and psychoanalysis.

15 Althusser, Louis, "Ideology and Ideological State Apparatuses", *Lenin and Philosophy and other essays*, New York: Monthly Review Press, 1971, p. 175.

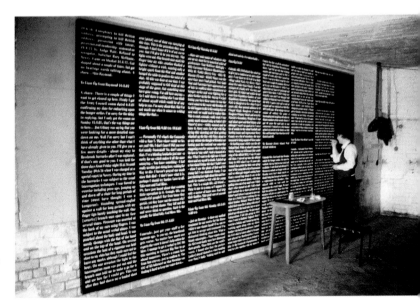

Shane Cullen. *Fragmens sur les Institutions Républicaines IV*, The Tyneside Irish Centre, Newcastle upon Tyne, 1996. Photo: Simon Herbert.

Althusser's attempt to convey how discursive formations situate the individual as subject is flawed by his unworkable notion of the always-already subject, which would have to perform as a subject before it had been constituted as such. Stuart Hall, tracing the legacy of Althusser's essay, argues that it is the failure of Althusser's argument on this point which can be used as another starting point in the analysis of identity. Hall accepts Althusser's central thesis that the subject is constructed by and through discourse, a position which Hall correctly notes is similar to Foucault's early investigations into subjectivity. Drawing on both Althusser and Foucault, Hall posits a view of identity as the point of meeting, or suture, between discourse (which is attempting to 'speak' us) and the processes which produce subjectivity. More metaphorically, we can see this as the chaining of the subject in the flow of discourse: "identities are thus points of temporary attachment to the subject positions which discursive practices construct for us."[16] Unlike Althusser though, Hall argues that the subject itself is always in process, always constructed in relation to what it is not. Althusser's problems with the subject arise from a particular reading of Lacan's mirror phase. In this reading, as Hall notes, every facet of the subject including the Law of the Father, the determination of sexual difference and the entry into language happens at the same moment. Hall not only contests this reading of Lacan, but also points out that Lacan's mirror phase is only one account of the way subjectivity is constructed. Instead of the idea that the subject is fully formed in a moment, Hall stresses the ongoing construction and reconstruction of the subject. Thus each moment of suture is necessarily only a contingent and temporary one.

It is precisely the suture at the point between interpellation and subjectivity constructed through Otherness and difference, that performance and time-based art can elucidate. The workings of interpellation are at the root of work by the Irish artist Shane Cullen. For his Locus+ project, Cullen meticulously hand-painted transcriptions of 'Comms', the smuggled out, hastily written communications of the early 1980s Irish Republican hunger-strikers. Both the Comms and Cullens' reworking of them are testament to how individual words and actions can come to constitute a discourse, which in turn will come to interpellate other subject-positions. The original Comms, written on cigarette papers, have been collected by the people of West Belfast, with certain ones such as those by Bobby Sands, achieving a cult status. Their growth in status has been reflected in the decision of the Irish government to start buying them to place in the Irish National Archive. Through this process, the written fragments became part of the narrative of the Irish state, and thus part of the body of texts which Althusser would have termed an Ideological State Apparatus. Oddly, some saw Cullen's installation *Fragmens Sur Les Institutions Républicaines (Panels 1—48)* as an objective representation rather than a commentary.[17] Nothing about Cullen's installation could claim objectivity; even the Bodoni font used is associated with the French Revolution. The impossibility of objectivity was heightened by the decision to present the catalogue in the form of an Irish legal document, and the reality of the power of language reflected in the offer by Locus+, in consultation with Cullen, to take down the exhibition in the wake of the Canary Wharf bomb.

opposite
Mary Duffy. *Stories of My Body*, 1995.
Photo: Michael Boron
© Project Arts Centre, Dublin.

16 Hall, Stuart, "Who Needs Identity?", *Questions of Cultural Identity*, Stuart Hall and Paul du Gay eds., London: Sage Publications, 1996, p. 6.

17 They were described as "operating as an objective anthropology rather than a memorial" in Locus+' catalogue.

To describe Cullen's images as "images for reading" is only half
the picture for inevitably, they are also words which will 'read'
other people.

While Cullen's reworking of discourse is a subtle affair, the nature of
performance art allows it the opportunity to more openly engage with
interpellation. This opportunity has been particularly welcome for those
groups who have always previously been spoken for; women, the racially
oppressed, the disabled, the colonised. For all these groups, a starting-
point has often been to engage with this very fact of previously being
spoken for, typified in Fanon's realisation, "You come too late, much too
late."[18] Homi Bhabha writes of Fanon's realisation of the belatedness of
his subjectivity, yet his insistence on reclaiming it undermines the
supposed civility and rational linear progress of the colonised world.
Thus "The Fact of Blackness" which takes the form of a highly charged
monologue, and from which the line comes, can be seen as a
performance, an attempt to repeat and re-perform the subjectivity which
has been simultaneously ascribed and denied. For Bhabha, minority,
belated subjectivity acts in a supplementary fashion in the sense of a
supplementary question, coming after the original question or in addition
to it, changing original proposals, undermining previous generalisations.[19]
It is this sense of the belated, supplementary performance challenging
interpellation that comes out in the performances of Don Belton, Jan
Wade with Vanessa Richards, and Mary Duffy.

Wade and Richards' performance *Jazz Slave Ships Witness I Burn*,
which came at the conclusion of a performance residency by Wade
contested the discourses of colonialism and slavery which have spoken

18 Fanon, *Black*, p. 122.

19 Bhabha, *Culture*, p. 155.

above
Jan Wade and Vanessa
Richards. *Jazz Slave Ships,
Witness, I Burn*. Vanessa
Richards as Mary Christian
Grassett, Wilberforce Museum,
Kingston upon Hull, 1996.
Photo: Jon Bewley.

those in the African diaspora. By siting one of the performances in an eighteenth-century bonded warehouse in the English port of Whitehaven, Wade and Richards signalled their intention to re-situate themselves within those interpellative discourses, and with a supplementary, belated act, contest their authority. Richards assumed the identity of a young, black slave-girl but this was not a reclamation of some authentic black, transhistorical identity. Ironically the only thing known about the girl is that she was classified as a "mulatto", and thereby, as Robert Young might say, inscribed within difference. Richards even admitted that she could not be sure whether the Yoruba Orisha songs she sung sounded anything like "authentic" Yoruba ("I sang as right as I knew"). The central focus of the performance, an altar made by Wade which was carried to the seafront, similarly, was a mixture of visual codes. Whilst the procession with the altar was a reclamation of history, it was not through positing a correct version of history, but rather it was a supplementary act, disturbing received narratives through re-presentation and restaging.

The physicality of the performance, from the carrying of the altar by members of the audience, through the placing of sugar in the audiences' hands through to Richards' invocations of other bodies was crucial, for the body has acted as signifier for identity through history, specifically through gender and race. The focus on the body in performance art works against both Althusser's and Foucault's assumption of the docile body marked by discourse, for performance can stress that these are active bodies, contesting the readings given to them. This was clearly and simply shown in Mary Duffy's performance *Stories of my Body*. The focus of the performance was unwaveringly on the artist's naked body which was caught, unmoving, in the glare of the spotlight. Duffy, whose mother was prescribed thalidomide during pregnancy, challenged the idea of the docile disabled body. The reclamation of agency lay in the refusal to be spoken for, even by kindly words. The performance drew on similar performances by first-generation feminists such as Carolee Schneemann, by both revealing how the Other is constituted in the gaze of the self and regulated by discursive authority.

Don Belton's performance, *Populuxe/Blackglama* also addressed the possibility of negotiating with the positions which speak the subject. Throughout the performance, memories from Belton's childhood were repeatedly contrasted with his adult understanding of his identity. The past was characterised, with a great deal of self-effacing humour, by his own ignorance of interpellative forces, "Still it was fun to be coloured those days—you just didn't know." The naiveté of this position was highlighted by the plethora of ethnographic, anthropological and racist discourses in circulation, which Belton alluded to through slides and a parody of an anthropological lecture. Belton did not straightforwardly contrast an innocent child with a knowing adult at ease with black identity. Instead he amusingly and honestly recounted his puzzlement at encountering "real" African women in the departures lounge for a flight to Africa: "I'm just not prepared for *these* African women." Belton's performance, a kind of restaging of *The Fact of Blackness* to a Diana Ross and a Jackson Five soundtrack with dancing, was characterised by a cheerful refusal to solidify subjectivity: "ain't no recipe for what I am."

So the climax of the piece, when he donned what looked suspiciously like net curtains and flailed around to the soundtrack, worked on several levels. Firstly it was a reclamation of black subjectivity. Secondly it was a liberating act, for he had previously recounted how his grandmother used to stop him acting out his Diana Ross persona. Thirdly, and most crucially, it was an affirmation of momentary identity and contingency. Throughout the Ross/Jackson Five pieces, Belton never suggested that he was fully identifying with the words and voices that were simultaneously speaking him and he was speaking. The suture, which Hall talks of, the moment of stitching your subjectivity to the discourse which speak you, was here in that self-consciously momentary performance, in the comic incongruity between Ross' singing voice and Belton's gruff shouting, climaxing in a glorious dissonant finale.

The importance of possibilities opened up by performance art and time-based art are crucial to exploring late 1990s ideas about identity. The optimism of 1980s identity politics, with the promise that you could be who you wanted to be, was shown up to be naive thinking by the end of that decade, as feminist and black visual artists soon found that the promise of a unfettered space was strictly limited to certain subject areas and types of work. Similarly the pessimism of postmodernism, where one is always spoken for by regulatory discourses, has been seen to be too extreme, and in its own way deeply Eurocentric. Critics were quick to point out that it was somewhat disingenuous to get rid of the Subject in its entirety just as the formerly colonised were trying to work through conception of postcolonial identity. Through the work of theorists working in a diverse range of fields, we have learnt that identity is neither fully ours, nor some other force's, but rather something both external and internal, something both incomplete and overdetermined, something both too soon and belated. Hall's argument about identity echoes Homi Bhabha's distinction between the pedagogical ("the process of identity constituted by historical sedimentation") and the performative ("the loss of identity in the signifying process of cultural identification"). It is from these almost identical positions that the most fruitful investigations into identity in the next few years will come. Bhabha's use of "performative" is telling. It is not simply reiterating the old idea of self-fashioning, as his use of "loss" to suggest that we perform to escape the identities set out for us, makes clear. Yet it attests to the continued importance of time-based work and performance in investigating identity. Fanon's performance, a towering influence on late twentieth-century studies in identity, ends on a downbeat note: "Without responsibility, straddling Nothingness and Infinity, I began to weep". Without falling into celebration, I would suggest there are grounds to suggest optimism in the project of understanding identities which can deal with difference both within, and without. From Nguyen's extraordinarily ambitious projection of a whole life, through Yuxweluptun's determined, knowingly pointless shooting, to Belton's affirmative shout of "Thank you Newcastle!" at the end of his performance, identity is up there to be grasped momentarily and shaken hard before it slips off again.

opposite
Don Belton.
Populuxe/Blackglama, Live Theatre, Newcastle upon Tyne, 1995.

AN INDIAN ACT SHOOTING THE INDIAN ACT

LAWRENCE PAUL YUXWELUPTUN

GLENN ALTEEN

In Canada Lawrence Paul Yuxweluptun is one of the best known painters of his generation. His work has also been exhibited extensively in Europe and America. Beginning with a combination of traditional West Coast imagery with Surrealism, that speaks to current issues especially environmental destruction, his paintings have received acclaim within British Columbia because they refer back to early modernist versions of this coast, paintings of the rain forest and abandoned native villages. These paintings spoke to the disappearance of the First Nations and used their own imagery to do it. Yuxweluptun turns this early art history on its ear: the white people are out of place and the landscape is in various stages of destruction. Clearcuts show up on distant mountains and toxic slag heaps abound. The First Nations inhabitants show the effects of the toxic environment and generations of assimilationist tactics. These are not pretty pictures but they're catchy. West Coast traditional native design represents one of the most refined and beautiful aesthetics ever developed, but Yuxweluptun's use of it shows he knows his Western art history as well. Pop Surrealism layered over a strong understanding of First Nations design make these intelligent works. They stand as contradictions with sad, ugly messages in a style that makes people want to look at them. Yuxweluptun's Glyphs and Morphs people a spirit world that mirrors our own—harsh Day-Glo colours a living landscape screaming in pain and outrage.

Lawrence Paul Yuxweluptun's performance work *An Indian Act Shooting the Indian Act* was a direct and provocative action. The shooting of the Canadian legal document, which governs relations with Canada's First Peoples, at both a rifle range and private estate constitutes a critique of the entire colonialist project. The action also exposes the historical presumptions that have resulted in the economic, social and legal positions that the First Nations of Canada must now live within. It issues the challenge that this legislation's time has passed and has no place in a modern Canada.

On other levels, *An Indian Act* questions European notions of the exotic aboriginal, speaking back to performance and visual artists who would revive outdated, romanticised notions of the 'noble savage'. Yuxweluptun didn't go to Britain to assist in spiritual development, instead he focused on a piece of legislation that Europe has given to America, specifically dehumanising legislation that enforces colonialist and paternalistic attitudes towards the land, the wildlife and the people.

Yuxweluptun's work always exists within a political framework. He never focuses solely on the past and the historical injustices to which the First Nations have been subjected. His work is always firmly focused on the contemporary conditions these communities must endure and it is in this spirit that *An Indian Act* was developed. Yuxweluptun is centred on its continued existence in Canadian Law and then on the ugly history it has facilitated.

above
Lawrence Paul Yuxweluptun.
An Indian Act Shooting The Indian Act, Document shot at Bisley Rifle Range, 1997.
Photo: Steve Collins.

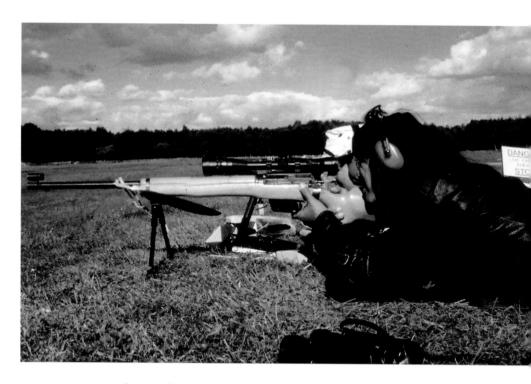

Because Yuxweluptun's reputation is based on his work in painting and drawing (he also produced an early virtual reality piece), performance is not a medium people would associate with him. When Yuxweluptun first discussed this performance he had planned on doing it in Canada. Later, he responded to Locus+'s invitation to take the piece to Britain. Although the Indian Act is one of the first laws enacted by the new government of Canada in 1868 it was based on earlier British legislation, most significantly The Royal Proclamation of 1763. The principles that make the Indian Act so odious a document were set in place by this earlier legislation. To the artist this Act represents "hate literature" and is indicative of the white supremacist views of British Colonialism. In many ways Yuxweluptun felt he was placing responsibility for the act where it lay. Few Britons are aware of this responsibility.

As interesting was Lawrence's presence as a North American Indian within the context of Europe. First Nation's people have been paraded through Europe since first contact, initially against their will, and many died from disease to which they had no resistance. Later Wild West shows continued to bring First Nations people to Europe to perform. And later different nations came to discuss land rights or treaties though never to much satisfaction. Many Europeans feel a romantic affinity for First Nation's culture.

above
Lawrence Paul Yuxweluptun.
An *Indian Act Shooting The
Indian Act*, shooting documents
at Bisley Rifle Range, 1997.
Photo: Jonty Semper.

In the performance *I Love America, America Loves Me* Joseph Beuys inhabited a downtown Manhattan gallery with a coyote for eight days. Beuys said the coyote represented the American Indian and the performance was about what America had given Europe. Specifically he

was referring to the shamanic traditions that were wiped out in Europe during the witch hunts. It illustrated European/First Nation relations throughout history, only the European was given the choice of participating. While the coyote is imbued with spiritual connotations his actual freedom is not a consideration. The coyote performs the role that the First Nations have played for the past 500 years. His co-operation is expected, his opinion not considered.

It was a Locus + conception to create multiples from the performance. We knew we would have defiled copies of the act but the gun and shell casings were a mixture of necessity and whimsy on their part. Appropriating the dark green felt and gold plaques of the legal profession turns authority on itself. It was a clever strategy considering there is some question whether shooting government documents is legal. Issues of firearms and hunting became subtexts in a country where wilderness no longer exists and the class system persists. In Britain the political aspects of the work were less controversial than the inclusion of firearms in its realisation. Yuxweluptun's use of the rifle at Bisley (a modified World War II Enfield sniper rifle) and the shotguns at Healey were the cause of much of the work's impact. The simple act of bringing an art audience to a working rifle range was a very significant aspect and perhaps the most memorable. In Healey the pastoral estate setting and the use of shotguns brought issues of hunting to the forefront.

During the performances at Bisley and Healey, Lawrence began the work by telling the audience they were there not to see a show, but to be witnesses. This role has both a traditional appointment and a modern one. In Northwest Coast traditions other nations attended feasts and ceremonies and were paid by the hosts to witness what occurred. In a modern context Yuxweluptun was recognising that the 'audience' for this work was in Canada. He began both works with the burning of traditional herbs in a smudging ceremony consecrating the space and the work. Later he plugged his ears and sat through versions of the Canadian and British national anthems played on a ghetto blaster. Only then did he begin the shooting.

At Bisley copies of the Indian Act were brought up one at a time, the shooting distance of 300 yards meant that Yuxweluptun drew on his skills as a hunter and marksman. In Healey the Indian Acts were put up in fives resembling the targets of a firing squad and shot in flocks or herds. At a distance of 30 feet and using shot made the targets sitting ducks. The firearms had been decorated with beads, ribbons and feathers, treating them as sacred objects.

The performances at Bisley and Healey were well attended with audiences bussed in from London and Newcastle respectively. This contributed to the feel of a weekend outing, although the rifle range was not a destination the audience would have necessarily been familiar with. The use and control of firearms in Britain is always an important issue, doubly so during Yuxweluptun's time in the country; the recent massacre at Dunblane had made Britain enact severe firearms laws that would curb long-held freedoms. Handguns were about to be banned,

and shooting enthusiasts were under threat of having their recreational activities made illegal. Yuxweluptun was familiar with recent initiatives in North America to control firearm ownership, a major political issue pitting urban and rural Canadians against one another; while in Britain where gun owners are much less numerous and hunting outside private estates impossible there has been less controversy. Consequently, debate has become much more entwined with class issues, a factor less visible in the polemics issued by the strong lobbies that exist in Canada and the United States. At Bisley the recent anti-firearms sentiments were a constant topic of conversation among firing-range officials.

After the performance a reception was held for Yuxweluptun at one of the pavilions at Bisley. There is a Canadian pavilion but the reception was in the Artists Rifles' pavilion. The Artists Rifles were formed in 1859 by a group of painters, sculptors, engravers, musicians, architects and actors in response to the threat of French invasion under Napoleon III. Prominent early members included John Everett Millais and William Morris. Noel Coward was a later conscript. Defunct since the 1960s when it was combined with other units and abandoned the Bisley camp, the site harks back to Britain's past imperialist ambitions and casts ironic tones over Yuxweluptun's endeavour. Even artists had a role in this struggle for supremacy, and Yuxweluptun's taking up of arms is a political struggle diametrically opposed to this earlier stance. The sides have changed. Imagine long-dead corpses tumbling in their graves. But Yuxweluptun leaves a bullet shell in wood and felt with its gold plaque that sits far too easily among the other trophies on the shelf.

In Healey the location of the site next to the pheasant stand pushed home the differences between the issues in Canada and Britain. These pheasants were raised by the gamekeeper unlike the wild game still extant in Canada. In Britain only the rich hunt. In Canada hunting is an important food source especially in First Nations communities and is a right under the Indian Act.

The owner of Healey Estate, Jamie Warde-Aldam, had to load the guns for the artist due to firearm restrictions, providing another consciously absurd touch within the larger project. He donned a pair of breeches to perform this role. Several people at the reception later mentioned the concept of enclosures (involving the transfer of common land to private ownership). As common land became more scarce in the nineteenth century, and the advent of the industrial revolution contributed to the migration of the work force from the countryside to the city, increasing numbers travelled to the New World. Land here was being offered to anyone who would farm it, thereby displacing the indigenous peoples.

Firearms have had a large role within the colonialisation of North America as well. They, and to a greater extent disease (germ warfare) made the take-over of America possible through the destruction of millions of First Nations' people in the first 100 years after contact.[1] Unfortunately firearms continue to have a place in many stand-offs with the government over land and rights.

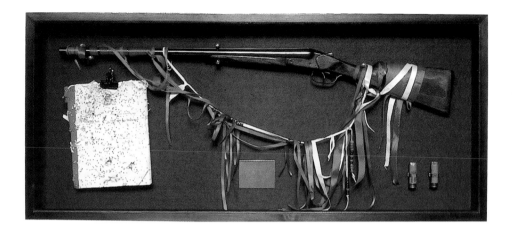

In Canada the project had its greatest impact. The focus returned to the actual legislation and the politics it represented. The Indian Act represents a stand-off between First Nations people and the Canadian Government. While nearly everyone recognises its racist and paternalistic nature, it does spell out special conditions for native people within the legal system. Before Yuxweluptun went to Britain, the Canadian High Commission described the Indian Act to a reporter as paternalistic and dormant. The reality is anything but dormant. Tied up within proposed changes are land claims negotiations and calls for aboriginal self-rule. In 1998 in official response to the Royal Commission on Aboriginal Issues the Minister of Indian Affairs spoke of the Indian Act fading away as changes on self-rule and lands claims came into effect.[2]

It is wishful thinking to believe that the Act will fade away. The whole history of Europeans and First Nations is tied up in this legislation. The Hudson Bay Company and small pox blankets, the banning of ceremonies, the broken treaties, residential schools and forced adoptions were all achieved through this legislation and its antecedents. Early amendments banned potlatches and ceremonies and a 1927 amendment made it illegal for First Nations Bands to hire lawyers to pursue land claims. Yuxweluptun's shooting of the document echoes the futility just as much as the Minister of Indian Affairs and Northern Developments desires to have it fade away. It is an absurd act in the late twentieth century but its demise is not so easily achieved for either.

above
Lawrence Paul Yuxweluptun.
An Indian Act Shooting The Indian Act, Multiple (edition of 3), 1997.
Collection of Vancouver Art Gallery.
Photo: Steve Collins.

It was this absurdity which gave this project its impact. To all of Britain and most North Americans the Indian Act was complete news. First Nations in Canada know it well for in it their lives have been defined: who is and who is not an 'Indian'. But it also impacts how their lives would be played out economically, socially and spiritually. The Indian Act kept natives from voting until 1960 (1970 in Quebec). While the official mechanisms which supported apartheid in South Africa have ended (though not the effects), reservations still exist throughout Canada where the inhabitants live in appalling conditions. Longevity rates for First Nations are still well below other Canadian and suicide rates on reservations are high. In Yuxweluptun's reasoning this act has facilitated the present state of aboriginal people in Canada today.

To most British and North Americans that old history has been put to rest. This is not, however, how the First Nations view it. Native defence of land and resources from encroachment is an ongoing struggle; native roadblocks a recurring summer event. During the 1990 Oka Crisis in Quebec one native elder was asked by the media if she was surprised that the military was called in. "Of course not," she replied, "They've always called in the military." [3]

Shooting pieces of legislation doesn't make them go away but it can embarrass a country that proclaims itself one of the most developed nations in the world and is purported to have the highest standard of living. The treatment of aboriginal people over the last 500 years of colonialism remains a blight on the American landscape. First Nations' people are waiting for control of land, resources and their own destinies though governments are not eager to negotiate. In British Columbia the Nisga, a people have recently negotiated a land claim, a self-rule agreement which will give them control of a piece of Northern BC (2,000 square kilometres, less than 5% of their traditional territory) as well as a sizeable amount of cash ($312 million) and self rule. The Nisga first began to negotiate with this country and province in 1887 (giving some idea of how long this process can take). Part of the agreement is the extinquishment of the Indian Act and all future claims to over 95% of their traditional territory. The agreement has to be ratified both provincially and federally, and opposition groups have done much to scuttle the process.

Legally, the First Nations are finally receiving support, especially in BC where treaties were never negotiated or lands conceded leaving governments in a precarious legal standing. The Nisga agreement represents a breakthrough although they are only one of many nations in BC who are in various stages of negotiations. But these negotiations work at a snail's pace and Yuxweluptun is not a patient man. He has watched generations of his family wait for agreements that are not forthcoming.

Post-colonialism leaves Canada in a very precarious situation generally considering its written history embodies the colonialist project. The very word "Indian" is based on European confusion as to where they were before deciding they were in India. That this confusion continues to this day ensconced in legislation is laughable. The name 'Canada' itself was

another misinterpretation by Europeans. When asked where they were by the European guests the Huron hosts answered 'Kanata', Huron for village. The Europeans thought they meant the surrounding territory. Over time some of these things are working themselves out. Over the past 30 years many First Nations have reverted to their own names instead of the names given them by Europeans. Eskimo has become Inuit, Sioux—Lakota, Naskapi—Innu etc. in attempts to set the record straight and empower communities devastated by colonialism.

Louis Riel was a nineteenth-century First Nations' leader hung for treason in 1885. In recent years he has been revived and revised as a father of confederation. He is said to have prophesised that the First Nations would sleep for five generations and then the artists would awaken them. In Canada today there is a renaissance of culture in First Nations' communities, originating in the revival of traditional art making practices and moving into contemporary work. The 1990s have witnessed the emergence of a generation of artists across Canada of First Nations' ancestry.

Colonialism and Modernism both painted a picture of native people that saw them as disappearing in a romantically doomed fashion. Post-colonialism and postmodernism are left to paint a different picture of communities, which are getting bigger, not smaller. Saskatchewan has a baby boom occurring now within the First Nations' community that will change demographics within that province. What is left for the Canadian government is to cease policies that attempt to assimilate Indians rather than allow them their own destiny within the Canadian confederation. Over the past 500 years disease, firearms, missionaries and generations of assimilationist tactics have never achieved the demise of the First Nations and obviously never will.

In early 1998 the firearm and shell multiples with defiled Indian Acts were exhibited at the grunt gallery in Vancouver along with documentary video of the performances. The appropriation was pushed further by painting the walls the same deep green and lettering the walls in gold. With the wooden cases, it looked like a gentlemen's smoking room. Within a year of the performance the Vancouver Art Gallery purchased a gun work and the Kamloops Art Gallery purchased the exhibition for their collection. The exhibition started touring early in 1999.

Reactions to the exhibition have been necessarily culturally biased. Non-First Nations Canadians respond to the politics of the work. They leaf through the gallery copy of the act amused at the audacity of the artist. But First Nations' viewers laugh loudly at the destroyed documents getting the joke immediately. Some are still giddy afterwards. Yuxweluptun is a Salish name meaning Man of Masks and is especially suited to Lawrence Paul. He is adept at speaking between cultures and combines humour and outrage seamlessly. Within *An Indian Act Shooting The Indian Act* focus shifts depending on the geographical, cultural or political ground on which the spectator stands. The multiplicity of meanings speaks to cultural differences and international perspectives and urges a real post-colonialism to commence.

1 Disease was the major killer of the First Nations people in the first hundred years after first contact with Europeans. Small Pox and Tuberculosis were the most prevalent, and wiped out millions. Disease spread faster than colonialism and by the time of the 'discovery' of the western half of North America many nations were already decimated by these plagues. There were many instances of traders collecting blankets from small pox hospitals in Europe for trade with the First Nations, hastening the process along. Whether this was an official policy or not remains speculative, but if not sanctioned it was tolerated and ignored. There were an estimated 200 million inhabitants in the Americas when Columbus landed. Guns were in the end much more secondary in this process.

2 The entrepreneurial enterprise that was colonialism was facilitated through this legislation and its predecessor. It carried economic, political, social and religious ramifications. Traditional religious practices were banned, including 'the potlatch', a northeast Coast traditional ceremony where feasting and gift giving were important aspects of determining social standing. Residential schools were institutions run by missionaries and the church where aboriginal children were boarded from the age of six. Within these institutions there was a mandate of beating the Indian out of the child. Traditional languages were forbidden and instances of physical, emotional and sexual abuse were rampant. The Canadian Government recently apologised for their hand in this ugly history and there is currently litigation against individual clergy and churches. In the late 50s and 60s forced adoption of native children occurred at an increasing rate in both Canada and Australia (which probably wasn't a coincidence). The Indian Act was amended and broken if need be to allow for colonialism. When First Nations did complain most disputes were settled in favour of colonialism and white settlers.
The Indian Act also created new political offices, ignoring or undermining First Nations, power structures. Traditional chiefs were unrecognised and band councils set up. First Nations are mostly matrilineal but for many years Indian status was passed through the father. Hence if a native man married a white woman she automatically became a 'status Indian'. First Nation women who married white men lost all status and rights under the act.

3 In 1990 a skirmish broke out between the Quebec police and the Mohawk nation over a traditional burial ground being usurped for a golf course. One policeman was killed and eventually the Canadian Military was called in for a standoff that lasted months. This action polarised the situation with First Nations' people in Canada. The Mohawks were given support from native groups across America and the potential for bloodshed loomed large.
The Mohawk Confederacy, also called the Six Nations Confederacy, was one political structure that survived the Indian Act. Aspects of this confederacy were earlier adopted by writers of the American constitution. The defence of their territory partially within the Canadian provinces of Ontario, Quebec and upstate New York has demanded of them considerable polictical acuity. During the Oka Crisis they were adept at both handling the media and the military. The golf course was never built. Oka did represent, for the First Nations of Canada, a line drawn in the sand comparable to the Wounded Knee standoff in the US a generation before. Out of it emerged a new generation determined to defend their traditional lands with whatever militancy was necessary.

A DAY AT THE RACES

MARK WALLINGER

PAUL BONAVENTURA

Jim McGrath once wrote that few occasions in racing history can match the day when Dawn Run became the first horse to add triumph in the Cheltenham Gold Cup to victory in the Champion Hurdle. The Irish mare had taken the hurdling crown in 1984, but found the transition to fences problematic. The 1986 Gold Cup was only her fifth steeplechase but, such was her following, she still went off favourite. Her main rivals were the 1985 winner Forgive 'N Forget, the often brilliant Combs Ditch, the front-running Run and Skip, and Wayward Lad, winner of the King George VI Chase at Kempton Park three times and the third of Michael Dickinson's first five home in the 1983 Gold Cup.

McGrath, Channel Four Racing's paddock commentator and a director of Timeform, the largest information service on racing, takes up the story four furlongs from home. "Of the five principals only Combs Ditch was not in contention as they swept down the hill towards the third last fence, but the fast pace which Dawn Run had set in the earlier part of the race looked like taking its toll as she was joined by the more experienced Wayward Lad, Run and Skip and Forgive 'N Forget... Run and Skip lost his place almost immediately and at the last it seemed to be between Wayward Lad and Forgive 'N Forget, but half-way up the run-in Dawn Run started to rally. As the mare went past Forgive 'N Forget, Wayward Lad was still three lengths up but, dead-tired, he started to wander to the left. Spotting this sliver of hope, jockey Jonjo O'Neill asked Dawn Run for one final effort, and the horse slogged on courageously to beat Wayward Lad by a length, with Forgive 'N Forget two and a half lengths further back in third. The scenes which followed are as famous as the race itself, with horse, jockey, and connections being mobbed by a delirious crowd an they made their way back to the unsaddling enclosure."[1]

1 Magee, Sean, *The Channel Four Book of Racing*, London: Sidgwick & Jackson Limited in association with Channel Four Television Company, 1990.

Mark Wallinger did not back Dawn Run that day. However, the excitement generated by her gallant display so overwhelmed him that he was obliged to carry himself off to the Accident and Emergency Department of his local hospital with severe heart palpitations. "It was such an exciting finish," he said in 1994, "and so stirring how Dawn Run came back at the end that the old 'ticker' felt like it was about to pack up. So I went 'round to casualty and they gave me a card on which I filled out my symptoms. I was escorted into a cubicle and onto a trolley and the curtains were drawn across. Electrodes were placed all over me and I was given a scan and left lying there for what seemed like a very long ten minutes. When they came back, they told me that I was perfectly well so I rose like Lazarus and left."[2]

As of summer 1999, Mark Wallinger is probably best-known for *Ecce Homo*, his contribution to the FourthPlinth exhibition in London's Trafalgar Square. In part, the contemporary life-size statue of Jesus serves as a reminder of our responsibilities as citizens and adds to the vociferous discussion surrounding the issue of cultural identity at the start of the new millennium. Prior to *Ecce Homo*, however, the artist's interrogation of identity had given birth to one of the most unconventional artworks of recent years, a thoroughbred racehorse called *A Real Work of Art*. Ideas don't come much more convoluted than those pertaining to identity, but in his large body of work which relates to the turf—*A Real Work of Art* included—Wallinger has created arguably one of the most clear-sighted cross-examinations of nationality and belonging to come out of Britain this century

The equine sources which Wallinger plundered for his work of the early 1990s include *Stallions of 1991*, a reference book for breeders advertising the potential qualities of thoroughbreds at stud, and the shabby merchandise commemorating the career of Desert Orchid, the flamboyant grey gelding whose exploits captured the imagination of jump racing's enthusiastic public at the tail-end of the 1980s. Nonetheless, the artist identifies the stirring finale to the 1986 Gold Cup as the defining moment when he first began to contemplate seriously the possibilities offered up by horse-racing as a suitable subject for his artistic enquiries. *A Real Work of Art*, the two-year-old chestnut filly which represented the culmination of his turf-related concerns, was conceived in that heart-stopping moment up the notorious Cheltenham hill when Dawn Run snatched victory from the jaws of defeat.

Art and horse-racing have long been for Mark Wallinger the most exciting and rewarding of his intellectual and emotional interests. As a teenager, he carefully nurtured what has since become an abiding fascination for the greatest moments of turf history and ranks particular horses and races alongside certain works of art as providing him with his most cherished memories. Like art, horse-racing as a discipline subscribes to its own set of invented rules and it was probably inevitable that at some juncture he should work with the activity which mirrors in its fictions his own profession and provides him with so much enjoyment.[3]

2 All quotations by Mark Wallinger are from a conversation between the artist and the author. An edited extract was published as "Turf Accounting", in *Art Monthly*, no. 175, April 1994.

3 Part of this article was first published in *Vade Mecum: A Compendium of New Art*, Newcastle upon Tyne: Locus+, 1994.

Self-evidently, horse-racing is about horses. Like many other nationalities, the British have developed a long and well-established relationship with the animal, looking upon it at various times as companion, servant and object of religious veneration. Nowhere, perhaps, is this better illustrated than in the figure of Epona, the Celtic goddess whose iconography was inextricably linked with the horse. The particular attraction surrounding Epona lies in the representations of her for she was never portrayed without her equine sorority. Her femininity and that of her horses have been associated with fertility and healing and she is thought to have symbolised, for Celts and Romans alike, the deep mystery of rebirth and the supremacy of life over death. For devotees of the cult, the goddess Epona and her female entourage represented the future.[4]

4 For further information on the cult of Epona, see Green, Miranda J., *Dictionary of Celtic Myths and Legends*, London: Thames and Hudson Limited, 1992.

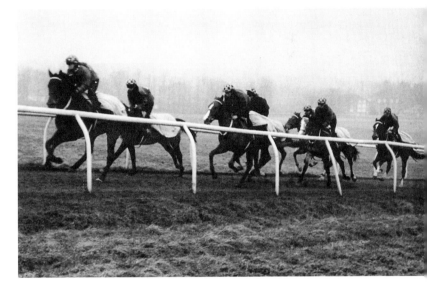

Seen in the context of the rigidly patriarchal world of horse-racing, the issue of gender takes on an uncommon significance. The Jockey Club, the controlling body which formulates, administers and enforces the Rules of Racing in Britain, is exclusively male. The vast majority of trainers are still men and women make up only a small proportion of jockeys. Traditionally, the qualities of a thoroughbred are seen to derive from its paternal ancestry and stallions are prized and valued far in excess of brood-mares.[5] The fact that Dawn Run was female only added to her special appeal for no other mare has taken the blue ribbon of National Hunt racing. In assembling upwards of six pieces of work which touch on the importance of gender and pedigree in horse-racing, Wallinger has suggested that the dominant patriarchy which sustains the sport maintains its position by virtue of its numerical dominance and senses flaws in what is frequently thought to be the quasi-science of breeding:

5 "I was waiting for someone in the pub the other night and thought it would be fun to denote myself in the way that horses are—in which case I would be a thirty-five year old white man by Jim Wallinger out of an Arthur Candy mare!" Wallinger / Bonaventura, "Turf", *Monthly.*

above
A Real Work of Art in training (third from left), 1994.
Photo: Jill Ritblatt.
© Mark Wallinger

A lot of very well-bred horses aren't particularly good and end up racing round the smaller courses like Market Rasen and Plumpton.

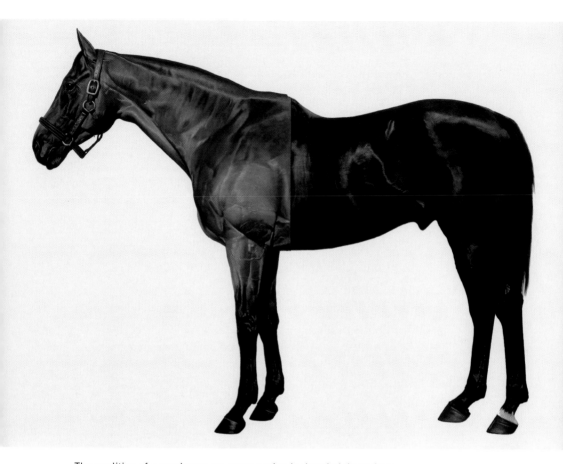

The qualities of a racehorse are supposed to be handed down from its sire and maternal grandsire, but I'm not so sure that this is always the case. Those really good brood mares Height of Fashion and Stilvi produced the top two-year-olds for three years in succession. A good mare may keep going for up to fifteen seasons, but that only means fifteen offspring rather than the hundreds which a stallion is capable of producing over the same period. The whole of the bloodstock industry relies on stallions being seen to impart their characteristics to their descendants.

For someone who can only view the Grand National from between his fingers, it was obvious that Wallinger would choose to focus his artistic attentions on the less dangerous and infinitely more prestigious discipline of flat racing, an environment dominated by vast sums of money and wafer-thin certainties of form. The first work to categorically parade its maker's interest in this area was *Race, Class, Sex* (1992), a quartet of full-length paintings featuring some of the most exceptional thoroughbreds from the 1980s. Dancing Brave, Shareef Dancer and Reference Point were all top-class middle-distance horses and Soviet Star was a brilliant miler. In 1992, they represented the apogee of the breed.

above
Mark Wallinger. *Half-brothers,*
(Exit to Nowhere–Machiavellian),
1994–95.
Collection Tate Gallery London.
© Mark Wallinger

All racing thoroughbreds can be tracked back over twenty-three or twenty-four generations to just three Arab stallions—the Byerley Turk, the Godolphin Arabian and the Darley Arabian—imported into England from the Middle East in the late seventeenth and early eighteenth centuries. The most influential of the triumvirate was the Darley Arabian, great- great-grandsire of the legendary Eclipse, widely held to be the finest racehorse of all time, and progenitor of the four quadrupeds which make their appearance in *Race, Class, Sex*. At one time, all four stallions were in the ownership of members of the Maktoum family. Sheikh Mohammed and his three brothers officially rule the Gulf state of Dubai. Unofficially, for the past two decades, they have also ruled British racing. Collectively, the family is estimated to have put more than £2 billion into the sport since 1982 at a time when British owners have been feeling the pinch of recession. On occasions, horse-racing in this country has seemed like a private family competition.

> Sheikh Mohammed is the largest player in the racing game so it seemed that the most obvious thing to do was to pick stallions from his Dalham Hall Stud for this first piece of work. I liked the idea that three hundred years on from the Darley Arabian, an Arab owner should spend so much money buying back the breed. I was intrigued by this historical nicety and by the fact that Stubbs had painted Eclipse, their collective forebear.

As a title *Capital*, the series of seven canvases which Wallinger painted in 1991 to stimulate debate about how the homeless were portrayed on the streets of London, irritated some viewers so it amused the artist to allude so forthrightly to three other weighty issues in *Race, Class, Sex*. "If horses run under Rules, they run in certain classes of race and class is a term that one often hears when thoroughbreds are under discussion. Once a stallion has gone off to stud, its sole function in life is to have sex... I liked the way that the three words operated as puns, but the title isn't really that fanciful, encompassing as it does both ownership and signification." In much the same way that the polyptych of human studies made reference to one of the most significant analyses of the socio-economic situation in Europe in the second half of the nineteenth century, so *Race, Class, Sex* calls forth associations with Angela Davis' *Women, Race and Class* and the American civil rights campaigns of the second half of the twentieth century.

Notwithstanding his fervent ideological beliefs and genuine anger at moral injustice, Wallinger is only too aware that his interest in the turf does, on occasion, compromise his avowedly political position as an artist. "I went to Royal Ascot in 1991 and sat in the bar at Tattersalls for three hours before the first race with The Sporting Life and a race card and felt just about as happy as I ever could. I thought 'I belong here'." The class divisions which make themselves felt at times like these became the subject of two video pieces which Wallinger conceived in connection with two of the most important fixtures in the flat racing calendar. *Race, Class, Sex II* (1994) reveals the behaviour and reactions of portions of the crowd in each of the increasingly more expensive enclosures during the course of a five-furlong sprint at Glorious Goodwood in August. Similarly, *Royal Ascot* (1994) portrays the pomp

and ceremony surrounding the Queen's cavalcade as it processes along the finishing straight prior to the first four days of the Royal meeting in June.

The genealogy of the racehorse and the supremacy of the male bloodline come in for further scrutiny in *Fathers and Sons* (1993). The piece comprises four paired canvases depicting famous sires with one of their equally famous offspring. After *Race, Class, Sex*, Wallinger wanted to do a series of smaller paintings which picked up on the semi-playful aspects of the earlier series. As the paintings are portraits, we are encouraged to think of the subjects as specific individuals and compare the similarities and differences between generations. They are stamp shaped, which sparks a reverberation with the widely used equine term "a fine stamp of a horse", and the fathers are stacked over their sons to indicate lines of succession: Mill Reef above Shirley Heights, Great Nephew above Shergar, Blushing Groom above Nashwan and Sharpen Up above Kris.

> What I find both funny and disturbing about the series is the degree of anthropomorphism with which one invests the subjects. A dumb sort of oedipal psychological interplay is enacted between the parent above and the offspring below. By placing them one above the other, I'm offering viewers an opportunity to size up the similarities and differences between the two animals and ponder the consequences. For example, Mill Reef won the Derby, a distance which Sharpen Up famously failed to see out, and yet Sharpen Up sired a much better son in Kris than Mill Reef did in Shirley Heights... Maybe my unease in all this stems from a consideration of its human implications, about the implications of characteristics being handed down and improved upon generation by generation. I'm disturbed by the thought that I am a predetermined biological product, that how I perform is in my cellular make-up.

The chilling consequences aroused by the prospect of eugenics find another outlet in a more recent set of paintings, a group of four diptychs entitled *Half-brothers* (1994-95) in which the front half of one colt is brought together with the rear end of a maternal blood-brother: Diesis with Keen, Unfawain with Nashwan, Jupiter Island with Precocious and Exit to Nowhere with Machiavellian. The complexity of that relationship between a colt and its half-brother and the crucial role played by breeders in determining the outcome of any equine coupling receive further treatment in *Behind You* (1993), a half-equine-half-human assemblage in which a fancy dress horse outfit has been arranged over two male dummies seemingly engaged in an act of buggery, and in *National Stud* (1995), a wall-sized projection of the ritualised covering of a mare by a stallion at flat racing's headquarters in Newmarket. [6]

6 The farcical sense of being 'caught in the act' which this piece evinces is captured in a black and white photograph called *The Full English* showing *Behind You* at night under a tree at the end of a suburban garden.

By 1993 Mark Wallinger had ventured even further into his enthusiasm for the turf by registering as a potential buyer. Any owner of a racehorse in Britain has to enrol his or her colours with Weatherbys, the company which implements the regulations governing racing and oversees the day-to-day running of the sport. The artist subversively chose as his own colours the green, white and violet of the Women's Movement.

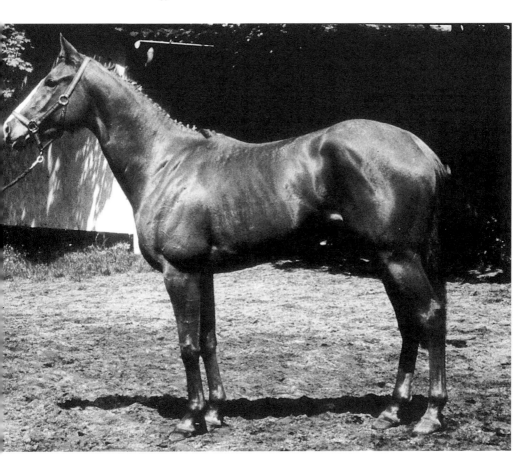

In 1913 Emily Davison threw herself under and brought down the King's horse at the Epsom Derby. Davison and the King's Jockey, Herbert Jones, both lay unconscious on the turf for a while so in a way these colours are an amalgam of those two figures who just happened to coincide at a particular historical moment. While being carried away, Davison was found to be sporting the 'Give Women the Vote' colours of the Suffragettes.

Wallinger clarified the provenance of his selection and paid homage to the significance of the event by visiting Epsom in his own silks in 1993 and in drag to have himself photographed at Tattenham Corner as an amalgam of artist and activist, a Rrose Sélavy for the 1990s.[7]

7 Rrose Sélavy was the female alter ego of the French artist Marcel Duchamp.

The importance of colour in art plays a pivotal role in *Brown's* (1993), a series of canvases which depict the colours of forty-two racehorse owners with the surname Brown. *The Benson & Hedges Book of Racing Colours*, a copy of which Wallinger owns, shows in diagrammatic form all 14,000 colours currently on record, each looking "like the costume change for an invisible man." The acceptable permutations of design and hue are strictly enforced—choices have to be made from a palette of

above
Mark Wallinger. *A Real Work of Art*, 1994.
© Mark Wallinger

A REAL WORK OF ART

eighteen colours and a picture book listing of forty separate distinguishing markings—and Wallinger takes pleasure in the fact that decisions which owners can make about the colours and markings which represent them in perpetuity are delegated to others and "that the flipping back and forth from decoration to denotation (is) signalled by a single possessive apostrophe." Racing silks are often referred to as colours and if all available pigments were to be mixed together, the theoretical result would be a sort of muddy brown so there is also a poetic connection in the work with the act of painting itself.

The enormous success of the National Lottery lends credence to the notion that gambling in all its forms probably panders to a deep psychological need in each of us to lose. Undoubtedly, betting is a foil for adversity. As a counterpoint to deprivation, winning is a compelling fantasy. But as a solution to life's iniquities, it is more of a tease than

above
Mark Wallinger. *A Real Work of Art*, die-cast statuette (edition of 50), 1994.
Photo: Rob Sargeant.

anything else for at its core resides the unstable nucleus of hope. "Bookmaking is representative of the purest expression of capitalism. Money plays a spiritual role in racing representing the possibility of transmutation. In gambling on horses nothing is bought or sold or exchanged other than people's hopes." The language in which bookmakers conduct their business only adds to the mystique of gambling. Slang terms are used to describe odds, amounts of money, horses and other aspects of the betting operation. For some words and phrases, the derivation is reasonably obvious; for others it is more obscure. *Monkey* (1992), a simple work comprising £500 worth of £5 notes stuck to the surface of a wooden support, gives substantive form to one of the more widely recognised units of on-course betting.

Towards the end of 1993, Wallinger turned the gesture of registering as an owner into a reality, approaching the Newmarket-based trainer Sir Mark Prescott to see whether he might be willing to purchase for him a two-year-old racehorse for the coming season. Sir Mark returned from the end-of-year Tattersalls Sales in Ireland with a yearling, a chestnut filly by the miler Keen out of an unraced dam by Roberto. Having the terrifically fast Sharpen Up as her paternal grandsire and being three-parts sister to the prolific American winner Neshad, the filly inspired a degree of confidence that she might make up into a precocious sprinter and went under the hammer for 6,600 Irish guineas.

Wallinger chose to christen the filly *A Real Work of Art*, conferring on her unhesitatingly the status attached to a fine art object. His choice of a flesh-and-blood ready-made, a speedy found object which remained as blissfully unaware of its role as a work of art as it was of its role as a racehorse, reaffirms the right of all artists to nominate anything which comes to hand as art. Furthermore, his designation extends and builds upon Marcel Duchamp's original iconoclasm by assigning the status to a living being and one which is other than human.[8] With her broad white blaze and intelligent countenance, *A Real Work of Art* is as pretty as a picture and the artist once intended to immortalise her looks in oils in a full-length portrait. However, a likeness of her already exists, for in order to finance his acquisition the artist ordered, from a small commercial foundry, an edition of fifty die-cast metal statuettes of the filly. The purchasers of the statuettes and the consortium of art collectors, curators, arts commissioning agencies and gallery owners which met the real filly's training fees were acknowledged by Wallinger as an expediency. Regardless, the range of undertakings represented in both partnerships reflected the sorts of compromises which sustain most dealings in the art world and allude to the interdependence of producer and produced, intermediary and audience.

Audaciously, *A Real Work of Art* cantered around the very margins of aesthetic practice. The recognition of any object as artwork involves a prodigious leap of faith on the part of the onlooker and that object only exists as a product of the creative imagination for those who accept its credentials. In devising and popularising the notion of the ready-made, Duchamp trained the spotlight on the function of the maker in this contractual relationship, choosing to offer up for reflection in museums and galleries objects which already played a pre-existing role in the

8 In "Horsing Around", The *Guardian's* James Hall wrote: "The concept of 'live' works of art is hardly original. In the early sixties, Piero Manzoni's signature on any part of your anatomy was guaranteed to turn you into an 'authentic and genuine work of art'. In the late sixties and seventies, Jannis Kounellis exhibited horses and birds; Joseph Beuys shared a cage with a coyote; and Gilbert & George declared themselves Living Sculptures." What Hall seems to forget insofar as *A Real Work of Art* is concerned is the fact that Wallinger's gesture has been officially sanctioned by Weatherbys, the company with which all racehorse names must be recorded. The company receives about 10,000 applications for the registration of new names each year and turns down proposed names on the grounds of content or taste. Weatherbys' acceptance of Wallinger's argument that his filly is *really* a real work of art as well as a racehorse is beyond official dispute. See James Hall, "Horsing Around", *The Guardian*, Monday 25 April 1994.

theatre of the real world. With his artful filly, Wallinger selected something of no intrinsic worth, acknowledging and embracing the fundamental role played by the viewer in the formulation of a new work. Its meaning, in other words, resided just as much in the collective aesthetic experience of the audience as it did in the aesthetic determinism of the maker. It's art, stated Wallinger, because I say so, but only if you agree.

In *Fountain* (1992), a work named in emulation of Duchamp's glazed earthenware urinal of 1917, Wallinger commented on the ways in which institutions not only endorse the decisions made by artists, but actively participate in those choices. The hosepipe which issued out of the locked Anthony Reynolds Gallery at ground level sent a ceaseless stream of water pissing into the gutters of Dering Street, a thoroughfare in central London which has become synonymous with the origination and exhibition of contemporary art. After its piecemeal journey through the capital's conduits and sewers, the stream re-entered the Gallery through the plumbing in its basement to continue its circulation around a self-contained system, a metaphor for the structure which provides much leading-edge work with its justification and permission and from which the public are studiously excluded.

> A lot of contemporary art claims allegiance to the ready-made tradition, but there seems to have been an inversion of power inasmuch as it is the institutions and galleries which sanction and give authority to the objects and activities which come under their aegis. So in fact (those artworks) become deeply conservative gestures reinforcing the power of institutions which decide the value or quality of the work and in which the public are used as dupes to play the game of outrage.

With *A Real Work of Art*, Wallinger attempted to short-circuit representation by showing the thing itself. In choosing a living being whose existence is shaped by formative synthetic mechanisms other than those connected with the presentation of art, the artist ceased to call for support on the legitimising infrastructure of the gallery. Therein resides its radicality.

> To buy a horse myself and to nominate it as an artwork seemed like the only logical conclusion to everything which had gone before... In choosing a racehorse as the subject of the piece, I am signalling the fact that the thoroughbred is already an aestheticised thing, its whole purpose being to give pleasure to its owners and followers. By choosing a racehorse, I am presenting something which functions as a history of aesthetics in microcosm and this is one of the reasons why I decided on the name... Once named she became a cipher in different networks of interpretation.

Like everything else about the underdeveloped juveniles which are two-year-old thoroughbreds, their shins and legs are extremely delicate. *A Real Work of Art* was due to make her first appearance on a racecourse in April 1994, but suffered a slight injury in training and was allowed to rest over the summer months. She was brought back to Prescott's

Heath House Stables in the early autumn and made her debut in the EBF Tormarton Maiden Stakes (Division 2) at Bath Races on Monday 26 September. The card mentioned that she "should have some pace judged on breeding and prospects may be indicated in the market" and she was sent off at odds of 7-1. Unfortunately, she finished tailed off after having injured her proximal cannon bone and required over two months' box rest to restore her to full health. During her convalescence, one of the members of the consortium of owners, the art collector Peter Vischer, offered to purchase all shares in the filly and she left Britain to continue her future in Germany.[9]

9 Her subsequent career generated one win and a whole clutch of places and she returned to Newmarket in the summer of 1996 to be covered by the accomplished middle-distance performer Belmez.

Although the project was interrupted by circumstances, this did nothing to undermine either its creative merit or integrity. *A Real Work of Art* developed its own discourse by being trained for and produced on the flat and through the reactions of the public and the press.

> The racing papers (ensured) that *A Real Work of Art* momentarily had significance for thousands of punters up and down the country. Every move she made was scrutinised in a way which no other artwork could hope to match. Her dual career produced an archive of data, photographs and recordings, all attempting to define her — all paradoxically rendering her a mediated image, as an abstraction. Her reality was consumed by the different criteria of meaning which were already in place to receive her...

For JSW

FRAGMENS SUR LES INSTITUTIONS RÉPUBLICAINES IV

SHANE
CULLEN

GAVIN MURPHY

Shane Cullen's *Fragmens sur les Institutions Républicaines IV* consists of ninety-six large tablet-like panels onto which the artist has transcribed meticulously in paint the contents of numerous Comms; the written communications smuggled in and out of H-Blocks between hunger strikers and their relatives and comrades.

The entire project has taken some four years to complete and was first shown by Locus+ in 1996. Given the uniformity and scale of the task—I would guess painting by hand the space within over 160,000 letters—this is quite a disciplined undertaking. Not surprisingly, this aspect is evident in several exhibitions held during its construction. For its Belfast showing at the Old Museum Arts Centre for example, there was a performative dimension to the work. Cullen himself was present in the gallery space painting several panels over four weeks. Indeed, one critic felt it significant that the painted work trailed off leaving only the pencilled outline of the words in the final panel (of 48) when shown at the Tyneside Irish Centre in Newcastle upon Tyne. In each case, more importance was placed on displaying work in progress (dynamic, unresolved) than marking the gallery as a repository for a final product (concluded, static).

It is perhaps inevitable that the chosen topic and its particular treatment has given rise to considerable debate. A key feature of this debate has been in its various contradictory claims. Where Brian Fallon reads the work as yielding a mere one-dimensional shock, Mick Wilson finds an intriguing complex of strategies at play.[1] Where Jenny Haughton celebrates Cullen's empathetic identification with the hunger strikes as a "union of subject and object", Peter Suchin stresses the exploratory nature of the artist's production as a defence against accusations of celebration or condemnation.[2] Where Peter Murray sees the artist removing evidence of his own individuality, Helen Swords reads it in terms of a "hand-crafted, painterly experience".[3]

It would appear that the key question is this: how are we to understand Cullen's work when various incompatible claims congeal around it? Any answer would have to consider the position of the artist in relation to the material he works. Material here points to two things: firstly, to the wider cultural and political context to which the work refers, and secondly, to the traditions of representation brought into play. And since the bone of contention among critics has shown itself to be at much a matter of the artist's political positioning as it is a question of the relevance of a marked authorial presence (or absence) in the work, attention should focus on the points of ambivalence and discord as these two areas intersect.

It is evident that Cullen appropriates the conventions and thematics of state acts of commemoration. The sculptural monument is central to such acts. Take a commissioned work such as Oisin Kelly's *Children of Lir* in the Garden of Remembrance (Dublin) as an example. This work plays a crucial role for the modern (Irish) nation state by enacting and solidifying historical narratives that privilege and legitimize the formation of the state. For Cullen to monumentalise the Comms and so mark the hunger strikes as a struggle for legitimacy is, in one sense, to recognize a key site through which such a struggle takes place.

The importance of commemoration as a site of political struggle should not be underestimated. It is central to Benedict Anderson's notion of the imagined community.[4] Here, the idea of the Tomb of the Unknown Soldier is taken as a key example of a commemorative site serving to link themes of collective sacrifice and fatality in war to the ideal of the nation state. Solemnity and reverence before the anonymous figure serve to gel kinship as a national imagining. Consider also the Vietnam War Memorial in Washington with its vast stretches of text listing the dead. This idea of the monumental edifice is echoed in Cullen's work through its the sheer volume of text, scale of presentation and its sombre, classical tones. Indeed, to echo forms of state commemoration serves to remind us that themes of death, sacrifice and fraternity underlie *official* acts of commemoration as well as those desiring them.

Cullen's work can also be seen to draw upon aesthetic structures through which the republic has been imagined in recent European history. The title of the piece relates to the writings of St. Just. The use of Bodoni fonts also draws a parallel with French Revolutionary

1 Fallon, Brian, "More Human Impact than Art", *Irish Times*, 14th August 1996; Wilson, Mick, "Fragments and Responses", *Shane Cullen: Fragmens sur les Institutions Républicaines IV*, exhibition catalogue, Orchard Gallery and Centre d'art contemporain de Vassivière en Limousin, 1997.

2 Haughton, Jenny, "And Now", *Shane Cullen: Fragmens sur les Institutions Républicaines IV* (Panels 1—48), exhibition catalogue, Newcastle upon Tyne: Tyneside Irish Centre, Gallowgate; Suchin, Peter, "Measured Words", *Circa*, No.77, Autumn 1996.

3 Peter Murray, foreword for exhibition catalogue, Venice Biennale, 1995; Swords, Helen, "Fragmens sur les Institutions Républicaines: An Object of Inscription", unpublished essay.

4 Anderson, Benedict, *Imagined Communities*, London: Verso, 1991.

opposite
Shane Cullen. *Fragmens sur les Institutions Républicaines IV*, The Tyneside Irish Centre, Newcastle upon Tyne, 1996.
Photo: Jon Bewley.

ow...

2.15 a.m.

r. I just heard the news - I'm
ust can't believe it. This is a
ng I have. I don't even know
Comrade, I'm sorry, but I
r anything else. May God in
ercy grant eternal rest to his
Christ protect and guide us

o

5.5.81 8.00 a.m.

his grief is unbelievable. I
must be wrecked out there.
me to tell you the truth. I

we all do - blanket men are more than
comrades - they are brothers. Therefore
our loss is all the greater. We all feel a
bitterness of immeasurable depth and a
very great anger at this callous act by the
British Government. From this has come
an even greater determination, to resist
and to fight back harder. It is a time for
total commitment by each of us as we
think on the ultimate sacrifice Bob made
and of the torture each of you are
enduring this very instant. We have taken
strength from his death and from your
resolve and I can tell you now that these
men have responded in a true Republican
spirit - totally disciplined and determined.
We all stand with you and we shall not be
shaken. We can succeed and we will
succeed. May God take care of each of
you and Bless you. - Bik -

We didn't talk much tho
there was anything in
prevent the Hughes famil
the same agony next week
power lay with the Brits a
implement a solution ther
more deaths and as far as
was on the cards. He sa
Bob and just after he star
me and said - 'we're p
Roberts aren't we?' (r
father) - I just said - that'
the heap I'll get back to
Take good care and God E

6.5.81 From Riasteard F

Alright comrade? Wil
insertion in the paper o
blanket men using the f

doctrine, while the austere monumental scale and theme of martyrdom recalls the neoclassical ideal as it was reshaped by artists at that time such as David.

To re-contextualise the Comms in this way is to connect eighteenth-century republican ideals to a present strain in Ireland. This is the most interesting aspect of the work. For it collides with a robust strand of contemporary criticism in Ireland that seeks to portray the hunger strikes as thoroughly dominated by what Richard Kearney calls a "mythico-religious tradition".[5] This is one where the sacrificial rhetoric of the hunger strikes is seen to operate as the "pre-reflective password of the tribe".[6] It is a pitch where Kearney sets his argument firmly within the de-mythologizing contours of secular reason and against what he terms as the mythic piety of modern Irish republicanism.

Cullen's work complicates such readings by calling upon classical republicanism as manifested in eighteenth-century France as a pertinent aspect to understanding present circumstance. This is to illuminate tensions between ethnic and civic forms of nationalism underpinning the history of Irish republicanism. Accordingly, it is necessary to take heed of the wider historical contours of this debate. This may be described in general terms as a clash between civic ideals of eighteenth-century republicanism and emergent forms of romantic nationalism—summarized by Martin Thom as a shift in commitment from the polis to aboriginal authority.[7] If this suggests a clear-cut movement from rational principles to mythologizing, circumstance should serve as a useful reminder of the blurred boundaries between

5 Kearney, Richard, *Postnationalist Ireland: Politics, Culture, Philosophy*, London: Routledge, 1997, p.110.

6 Kearney, *Culture*, p. 110.

7 Thom, Martin, *Republics, Nations and Tribes*, London: Verso, 1995, pp.13-29.

above
Shane Cullen. *Fragmens sur les Institutions Républicaines IV*, (detail), The Tyneside Irish Centre, Newcastle upon Tyne, 1996. Photo: Jon Bewley.

8 I am reminded here of Tom Nairn's comments on nationalism: "The most notoriously subjective and ideal of historical phenomena is in fact a by-product of the most brutally and hopelessly material side of the history of the last two centuries". See, Tom Nairn, *The Break-up of Britain*, London: New Left Books, 1977, pp. 335 and 336.

9 See, R. F. Foster, *Modern Ireland 1600-1972*, London: Penguin, 1988, p.11 and John Hutchinson, "Better than the Brown Earth—(or Shane Cullen's *Fragmens sur les Institutions Républicaines IV*", exhibition catalogue, Douglas Hyde Gallery, 1996.

the two. The French tradition of classical republicanism is very much coloured by a sacred dimension entailed in imagining civic virtue through fraternal intimacy and ideals of self-sacrifice, as indeed, romantic forms of nationalism can very much be seen to be born from an acute acknowledgement of material circumstance.[8] The point here is to acknowledge the presence and complexity of this dynamic rather than collapse it for political gain. Admittedly, Kearney does acknowledge to some degree the tensions between idioms of piety and secularity within contemporary Irish republicanism. Nonetheless, his reading of the hunger strikes places the event firmly in the realm of the former. In the light of this, it is worth acknowledging that the hunger strikes began as a short-term gambit—the strikers never expected it to go so far as it did. It was a gambit, moreover, not wholly coloured by the tradition of sacrificial martyrdom in terms Kearney speaks of. The custom of 'fasting upon' an enemy to force him into arbitration or 'fasting to distrain' where a creditor sought the moral high ground in order to force the debtor to pay up was an important feature of the old Gaelic civil code.[9] A legal procedure with a moral inversion and with material consequence (death meant compensation was paid to the bereaved family), it cut down on fatalities.

There certainly is a strong declamatory tone to this work. It upset one artist to the extent that Cullen was accused of being a "Nazi and an Irish nationalist". This prompted Cullen to release the following statement:

> I have never been a member of any political party or grouping nor do I hold any brief for the expression or dissemination of Nationalism or nationalistic ideals. The results of my practice as an artist exist purely because of my own independent phenomenological research and investigations.

This itself begs the question as to the relationship between the artist and the material he works with. For if a Republican monument is not being created what is?

For Cullen, the answer is a space through which to explore the complexity of history and its formation through the art object. For the viewer, though, evidence is needed as to how a critical distance is marked from polemical intent as a matter of experiencing the work (rather than simply accepting Cullen's statement). The work's indebtedness to the legacy of Conceptualism is an important factor aiding this. The visual economy of the work with its textual prominence and the eschewal of painterly competence as a means to confound traditional connoisseurship draws the viewer into its discursive terrain. It is one where effort is given to maintaining a rigorous and ongoing examination of the discursive and institutional settings through which art is made and understood.

Cullen's relentless marking of the body labouring in paint further encourages a focus upon the material process of making. It can be recognized as action operating within specific confines. The signifiers at play in this instance are the text itself and the painted marks that delineate it. It is in this sense that Norman Bryson's concept of *durée* is

crucial. It refers to where the gestural mark or brushstroke makes evident the time and labour of its making through the *wake* of its trace: hence Bryson's claim that the concept of the body is central in "the durée of its practical activity".[10] It has been noted how Cullen further stages the act of making, but its trace actually yields very little in terms of describing the experience.[11] It follows that what protects the work from claims of political intent is that the gestural marks invite us to consider their meaning but ultimately they never deliver.[12] An ambivalence haunts the act. But more than this, the painted marks call us back to consider the process of production.

Nonetheless, an uneasy tension persists, particularly if consideration is given to how the painted marks are subordinated to the demands of the typeface. Haughton's remark of there being a "union of subject and object" or Sword's claim that Cullen's "incessant re-inscription can be interpreted as an act of emphatic identification with the hunger strikers" seem to sit comfortably in the light of this apparent submissiveness. Furthermore, the scale and commitment involved in this work pushes Cullen's efforts into the heroic mode. This is a more than familiar feature of cultural production in Ireland. Seamus Deane characterizes it as being primarily concerned with the role art can play in the creation of a national consciousness. More specifically, Deane argues, it centres on the ideological conviction that a 'community exists which must be recovered and restored".[13] For this reason, the theme of restoring a vitality to the present prevails in this mode. To read the energy or *atmosphere* of Cullen's action as instinctive, spontaneous and unreflective in the light of worked material would tilt Cullen's production towards pure didacticism. And it should be remembered that the notion of the brushstroke as an emotionally authentic and spontaneous vision still retains a certain authority in contemporary art discourse.

10 Bryson, Norman, *Vision and Painting: The Logic of the Gaze*, London: Macmillan, 1983, p.122.

11 Bryson talks of the "irreducible life of the material signifier when dealing with the painterly trace". See, Norman Bryson, *Word and Image: French Painting of the Ancien Règime*, Cambridge: Cambridge University Press, 1981, p.27.

12 Barthes' definition of the gesture is useful here: "A gesture is the indetermined and inexhaustible sum of motives, pulsations and lassitudes that surround the act with *atmosphere*." See, Cy Twombly, *Catalogue Raisonné des oeuvres sur papier par Yvon Lambert avec un texte de Roland Barthes*, Vol.VI, 1973-1976, p.15.

13 Seamus Deane, "Heroic Styles: The Tradition of an Idea", *Ireland's Field Day*, London: Hutchinson with the Field Day Theatre Company, 1985, p.45.

It would seem that both these readings can operate simultaneously. In this light, the work slips between a questioning play with, and a passivity towards, forces involved in desiring statehood. But to appear repeatedly in a gallery setting is to place its didactic tones up for scrutiny. It is an expectation that the gallery viewer will explore and question in order to formulate a renewed awareness. To put a foot in the camp of the detractors, it could be asked where else would a potential 'monument' in waiting go? Three elements have been cited as a counter to this. In the first place, it is recognized that the work summons a complex historical dynamic as opposed to presenting history as myth. Secondly, it is acknowledged that Cullen's representational strategies draw on the legacy of Conceptualism. In this discursive terrain, attention shifts to consider the factual conditions of making. And thirdly, if we hold to the asemantic nature of the brushstroke, any imposition (notions of purity, spontaneity, etc.) can be resisted by allowing ascribed meanings to rebound to the point of collapse. At root, this is to hold to ambivalence in the work.

In this way it is possible to grasp what this work achieves. Its hyperbole is born from an audacity in mimicking standard commemorative devices of the modern state. The action and sense of time and space it creates leaves the suggestion that for the artist to understand republican or national imaginings is to physically confront the rhetorical processes involved in their construction (and the means by which this is cemented in history). In this sense, the work promises a polemic whilst simultaneously voiding one. Intrigue, lure and irresolution draw the encounter to a richer terrain of understanding—one stimulating a renewed awareness of the rhetorical roots of existing belief. And to take a step back from it all is to start wondering about those political needs and desires eclipsed by preoccupations with statehood.

above
Shane Cullen. *Fragmens sur les Institutions Républicaines IV*, The Tyneside Irish Centre, Newcastle upon Tyne, 1996. Photo: Steve Collins.

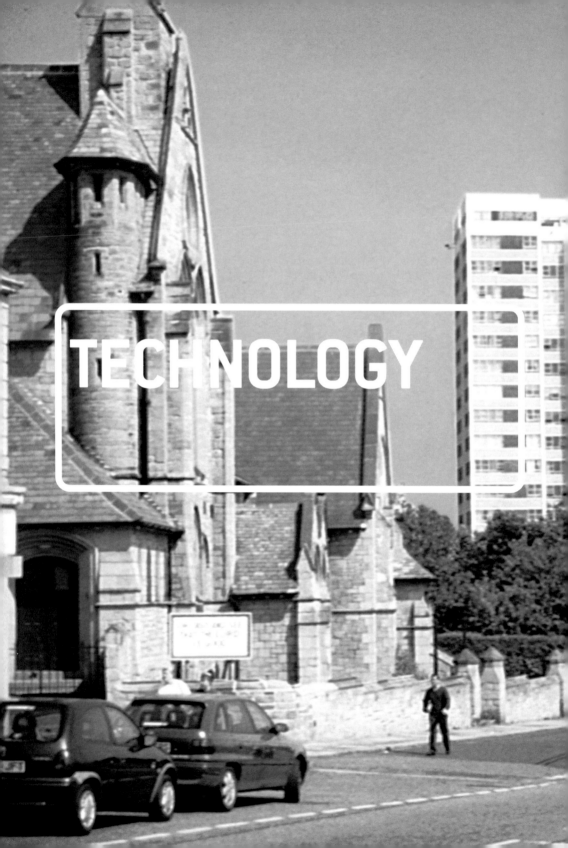

TECHNOLOGY

THE VANISHING:

WAR AND WASTE OR

THE ART OF MAKING THINGS DISAPPEAR

PAULINE VAN MOURIK BROEKMAN

THE DAY AFTER

To live with the legacy of atomic weapons and power is to live without the option of absolute refusal. It is to live even without the *illusion* of being able to refuse—a situation which those who lived through the transformative period of the Second World War might feel better describes their own predicament. Since the US conducted its Trinity test in the Alamogordo Desert of New Mexico and the Allied forces dropped their bombs on Hiroshima and Nagasaki, a Pandora's box has been forced wide open, causing not only enormous technological, biological and political fall-out but also permanently mutating our space-time coordinates. These bombs triggered chain reactions across all scales of material reality while simultaneously inaugurating a new era of cultural and political absurdism in which the logic, and language, of military rationality sanctions acts of irrationality; in which "destroyers of worlds" speak not the language of gods, but of bureaucrats. In their sheer metaphysical enormity, these founding moments renewed a loss of innocence: although large-scale destruction and the loss of human lives had been seen as a "necessary evil" of wars, and waste a necessary evil of energy generation, nuclear technology blasted the shadow side of these markers of historical progress and modernity into a thousand new dimensions. Time does *not* heal all wounds; nor is space immune to the invasive power of the split, or ionised, atom. Nuclear weaponry does not recognise the same geographical, physiological, cellular or genetic boundaries that traditional weaponry does. And so the dimensions now play host to a thousand of their filigree offshoots: spectral after-images propelled forward over millennia, deep into cells and across civilisations.

Now that this originary moment has passed, all that is left to us, those that came after, is participation in decisions about storage, disposal and future use. For our part, we persist in believing that if there is anything like absolute refusal left, these second or third order decision-making spaces—i.e. those of "management"—are the only ones in which it still has a place. Therefore, we seek our refusal in localised rejections: saying No! to nuclear waste, No! to nuclear reactors or No! to the stockpiling of nuclear weapons. But, radioactive material has suffused our world to the degree that each and every one of these prospective nuclear refusals on the part of one actor, one society, one state now marks an (often apparently enforced) nuclear acceptance for another. We may attempt to prevent the construction of *new* nuclear reactors in our own countries, but while we do, our governments—at the helm of the large nuclear corporations—are engaged in another series of negotiations which effectively rob our decisions of their finality. This parallel space of negotiation and competition is, of course, the global economy.

In the rule book of that global economy, nuclear power is still listed as an attractive good—stable if managed properly and, notionally, without limit. The armament and energy policies of most developed nations in the Western world and in particular those of the UK, France and the US, attest to this fact. However, this situation is dependent on these nations being tied into a global circulatory system which allows them the space and time, quite literally, to displace or defer (again, quite literally) certain aspects of the nuclear "life cycle". The UK's British Nuclear Fuels Ltd. has recently provided a good example. At the end of a period in which the UK operated a wholly different economic policy, namely one in which waste from *foreign* countries was often stored, or decommissioned on the UK's own shores, it is finally being made to feel the limits geography and public opinion can impose upon economic expansion. Consequently, it seems to be making some dramatic U-turns opting, in this instance, for storage overseas. BNFL, wholly owned by the British government, is one of several investors in a $10bn project to dump nuclear waste in Australia. A recent article in *The Observer* quotes BNFL official Bill Anderton as saying: "We are a company involved in the forefront of nuclear technology and we are always seeking innovative solutions. Because of practical considerations [the article cites opposition in the UK as one of these], it's inevitable that there will be some degree of international collaboration in the construction of waste repositories"—a classic melange of nuclear determinism, scientific boosterism and political spin. Britain, whose radioactive waste stock is second in size only to that of the US will be using roughly the same territory it used forty years ago to test nuclear bombs to bury its nuclear waste.[1] The waste will be radioactive for another 250,000 years. Another BNFL spokesman concludes: "Australia has the right geology and the political stability vital for a deep disposal site. We have to find a way of dealing with waste, and BNFL wants to be involved in the solution. We believe there would be substantial economic and other benefits for Australia."[2]

By virtue of such lateral moves nuclear energy generation *and* waste disposal can be re-classed as non-local issues: if the space and/or

1 Arlidge, John, "Don't poison us, plead Aborigines", *The Observer*, 21 February 1999.

2 Arlidge, "Aborigines".

political will for testing, storage or decommissioning does not exist in one locale, it can always be found in another. In our No resides the ghost of someone else's future Yes. The art of disappearance (an art in which human, technologically sophisticated cultures believe themselves to be masters) is the art of finding an *elsewhere*.

The Cold War and its ending have left us with a set of robust political-economic normativities. They steer conceptualisations of life with nuclear power as much as they steer any other cultural-political question. The decline and subsequent collapse of Communism, relative health and political stability of the West combined with an accelerated flow of goods and overall infomatisation of the global economy have bred a new creed of economic "pragmatism", which is being granted the status of a religious commandment. If one were to list—next to the primary dictum that the market is always right—some significant sub-components of this commandment, they would include the notion that some collatoral damage—in the form of unemployment, job insecurity and poverty—are a necessary price to pay for economic growth; that a combination of protective and anti-protective measures are necessary to boost exports while safeguarding the domestic economy from excessive dependence on imports; that redistributive economic policies negatively affect the economy and have (in extremis) been shown to fail in Communist Russia; and that, in the area of defence, unilateral disarmament is anathema to serious government. All of these should be placed against a backdrop of a kind of do-or-die view of the "evolution" of telecommunications technology and capital transfer; a wide-spread movement towards the privatisation of public utilities; and a frenzied trend of mergers and acquisitions, put into effect to rise to the challenge of global markets. Whether it is proponents such as Francis Fukuyama (of all of them perhaps foremost in the public consciousness due to his late 1980s thesis on the "end of history" and the universal victory of consumerism and liberal democracy) or, more aggressively, *The New York Times*' Foreign Correspondent Thomas L. Friedman (who, in his recent "Manifesto for the Fast World"[3] urges America take up its mantle of global policeman and espouses what he calls "the Golden Arches Theory of Conflict Prevention" according to which no two countries who boast a McDonald's will ever go to war), or critics such as *Le Monde Diplomatique* editor Ignacio Ramonet (whose term "La Pensée Unique"[4] hinges on the increasing hegemonisation of global culture, its brainwashing by the all-powerful machinery, kick-started at Bretton Woods in 1994, of an aggregate of global economic and monetary institutions, and its wrong-headed rejection of more communitarian political models in favour of something along the lines of The-Whole-World-As-Free-Market-America), these voices depart from one premise: we have entered the New World Order. One Market. One Net. One Culture. One Idea.

Like the operating principles of a kind of outsized game of *SimCity* —a SimNuclear—the various incarnations of this commandment cluster around a belief in the capacity to generate satisfactory levels of balance (and thus peace and prosperity) in global distribution systems.[5] The fact that scenario-building, a predictive management

3 Friedman, Thomas L, "A Manifesto for the Fast World", *The New York Times Magazine*, March 28, 1999 / Section 6.

4 Ramonet, Ignacio, *Geopolitics of Chaos: Internalization, Cyberculture and Political Chaos*, trans. Andrea Lyn Sacara, New York: Algora Publishing, 1998.

5 Released by Maxis in the early 1990s, this game became an instant classic and spawned numerous followers, e.g. *SimHealth* (in which the player attempts to balance the national health budget and achieve an efficient healthcare system aiming at universal healthcare provision). The games are predicated on certain ideological, economic and social 'drivers': although these tools' effects can be steered to equilibrium, the player is never able to change the tools themselves in any fundamental way, by implication thus effectively buying in to the game's economic and political rule set.

tool (pioneered in the 1970s by Royal Dutch Shell and now promoted, among others, through the Global Business Network) in which the long-term economic value of an organisation's present policies are tested against various wildly divergent but "internally coherent" futures, has become such an influential business tool illustrates not only the overflow from fiction into ideology that has always existed, but also the feedback loops from ideology, into simulation, and back into policy. In *SimCity* the hidden ideological drivers manifest themselves in the tools provided to the player to steer the city (increasing taxation scares off entrepreneurs and reduces the standard of living; decreasing taxation tears apart the social fabric by eroding public services; constructing parks and other public leisure facilities increases the mayor's popularity with the populace, makes re-election more likely, and so on). Ours are provided to us in more diverse—and, naturally, also less instrumentalist—channels, but are no less delimiting when it comes to finding an atomic *modus vivendi* that is globally sensitive in more than name alone.

Few would disagree that the changing role of the sovereign state is key in these various schemas, be they actual or simulational. As a strong state can serve to sustain social stability and cohesion just as much as it can serve to impose regulatory strictures on corporations, its continuing strength is far less inimical to multinationals than those who fear a corporatist drive towards infinite economic liberalisation and deregulation may believe. To thrive, corporations require the fertile ground that this social stability provides (in the form of both labour and consumer forces). Although the size, geographical spread and turnover of the largest multinationals makes them crucial actors in the global economy—many would argue that the dominant actors—the process, often pictured, of an ineffectual, gradually atrophying state cut off from the actions and decision-making procedures of an ascendant team of corporate big boys is far from accurate. Urban theorist Saskia Sassen has, among others, done much to contest the idea—seemingly congruent with theories of globalisation—that specific localities (financial, political and juridical centres, for example) and, in general, the geographical rootedness of economies matter little once goods, workers, factories and consumers are plugged into the hyper-accelerated flow of capitalised international exchange. In her book *Globalisation and its Discontents*, she discusses the manner in which, in this period of hybrid structures of governance, the state provides the corporation with indispensable services:

> Even though transnationalism and deregulation have reduced the role of the state in the governance of economic processes, the state remains as the ultimate guarantor of the rights of capital whether national or foreign. Firms operating transnationally want to ensure the functions traditionally exercised by the state in the national realm of the economy, notably guaranteeing property rights and contracts. The state here can be conceived of as representing a technical administrative capacity which cannot be replicated at this time by another institutional arrangement; further this is a capacity backed by military power.[6]

opposite
Gregory Green. *Double Bible Bomb*, 1996.
Photo: Peter Musato
© Gregory Green.

6 Sassen, Saskia, *Globalization and its Discontents; Essays on the new Mobility of People and Money*, New York, The New Press, 1998, p. 199.

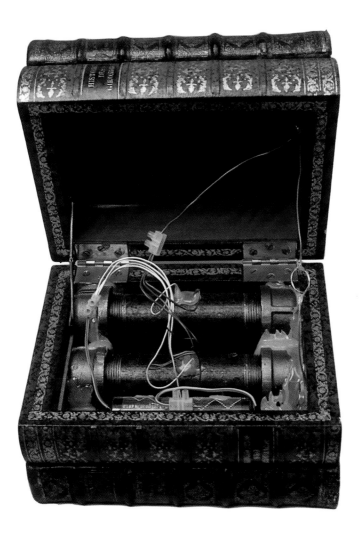

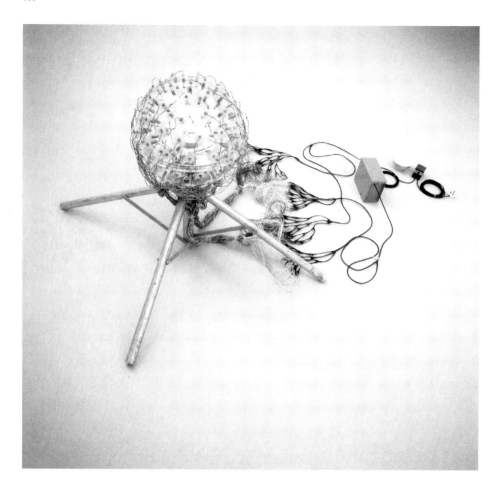

While transnational capital and information networks may be decreasing national state sovereignty on the one hand they are pushing towards its reincarnation as something altogether different on the other. As Sassen later says however:

> this guarantee of the rights of capital is embedded in a certain type of state, a certain conception of the rights of capital, and a certain type of international legal regime: It is largely the state of the most developed and powerful countries in the world, Western notions of contract and property rights, and a new legal regime aimed at furthering economic globalization.[7]

7 Sassen, *Globalization*, p. 199.

Sassen has repeatedly associated these forces with what she calls "the new normativities", a set of unspoken rules, masked as truths, which function to create the terms of any debate on what is and is not feasible in economic and social policy.

above
Gregory Green. *Nuclear Device #02 (10 Megatons Plutonium 239)*, 1995.
Photo: Anthony Oliver
© Gregory Green.

"J'ACCUSE..."

Gregory Green's catalogue *Manual II*, a publication of collected works, opens with the following battle cry:

> Established orders and systems produce conditioned responses which regard our governing system as the true guardians of freedom, while also pretending to be the one and only source of truth. The ruling order conceives and propagates the myths and illusions that maintain these responses. Their control of our perception is total and sacrosanct... We are told that we are surrounded by those who would deny us freedom and destroy our order. We are encouraged and coerced into a paranoid fear of that which is different. Ever increasing and unlimited power is offered as our only salvation from fear... The voluntary relinquishing of responsibility for our lives, actions and truths is the true source of our destruction. Freedom from this system of control based upon perpetual fear and misinformation is required for our own survival. The myths and systems that maintain these false realities must be removed.[8]

8 Green, Gregory, *Manual II*, Newcastle Upon Tyne and London: Locus+ and Cabinet Gallery, 1996.

The force of Green's embattled statement comes from its seemingly unequivocal depiction of contemporary reality—its univocal, vampiric pull on truth. However, as is the case with Cornelia Hesse-Honegger, whose representational schema forges a similarly grating relationship to both scientific and political apparatuses of authority and notions of representational verity, Green's relationship to realism (one which several commentators, including Maureen Sherlock in his case and Peter Suchin in the case of Hesse-Honegger, have drawn upon extensively) requires some elaboration. More so since realism is also at stake in the category errors attributed to both artists (the idea being that Hesse-Honegger's modest drawings should *either* belong to art—that safe haven—*or* scientific illustration; and Green's bombs, viruses and acid bottles are essentially no different, or not different enough, from the cultural objects they seek to critique).

An obvious precedent for any discussion on contemporary realism set against the backdrop of a consolidation of the One Idea System—as Ramonet calls the new normativities—is that held within German Marxist Aesthetic Theory from the 1930s to 1950s. Its principal participants (Theodor Adorno, Walter Benjamin, Ernst Bloch, Bertold Brecht and Georg Lukács) grappled not only with a suitable interpretation of global capitalism's—and thus in their view social reality's—definitive characteristic (as being either unitary or disjunctive), but also with the aesthetic imperatives these different interpretations created for artists. Georg Lukács' attachment to the term and the debate which his strident, if often dogmatic, commentary upon its status as the one-and-only socially relevant art form fomented, garnered a consciously structured and dialectical definition for realism which is light years away from its more popular understanding as a technique of naturalist or mimetic representation (admittedly not one which either Suchin or Sherlock employ directly). In his essay "Realism in the Balance", Lukács discusses the historical fluctuations in men's understanding of capitalist reality. He states that:

economic reality as a totality is itself subject to historical change. But these changes consist largely in the way in which all the various aspects of the economy are expanded and intensified, so that the 'totality' becomes ever more closely-knit and substantial.[9]

The apparent discontinuity and autonomy of capitalism's individual elements "constitutes only one part of the overall process. The underlying unity, the totality, all of whose parts are objectively interrelated, manifests itself most strikingly in the fact of crisis."[10] Quoting Marx, he goes on to say that:

Since they do in fact belong together, the process by means of which the complementary parts become independent must inevitably appear violent and destructive... The crisis thus makes manifest the unity of processes which had become individually independent.[11]

However much he remains a thinking, social and even politically radical creature, the limited cognitive abilities of the *Homo Somnambulans* Lukács pictures ultimately enable him to experience the truth of the totality only in moments in crisis—when the discrete elements of his reified habitat pull closer toward their innate proximity and crash together.

According to Lukács the realism this modern sleepwalker requires, possesses—at its very foundations—a thorough and relational structuring of the every-day reality he experiences in dialogue; in the street; or at work *with* the larger constructive capitalist social and historical forces which form its bedrock. Pointing to the shining beacons he sees in Classical and Enlightenment literature as much as in (then) modern figures like Thomas Mann (whose novel *The Magic Mountain* he regards as exemplary) Lukács posits that the unforgivable mistake the "apologists" of Expressionism and Surrealism make in their work is to unnecessarily shackle human consciousness to the reality it contemplates. This is, simplistically put, the question much of this debate on realism hinges and what makes James Joyce such an odious figure to Lukács—and such an example to Bloch or, for that matter, Theodor Adorno. Lukács despairs at the manner in which Joyce lets his subject act as a mouthpiece for the apparent aphorias and inchoate qualities of capitalist reality. The absurd, non-sensical montage techniques; the hybrid voices, which admiring critics offer up as masterful evocations of the modern *monologue intérieur* are rather, in his eyes, horrific instances of the double-vision of the *bad* realist crudely transposing qualities—themselves wrongly regarded as characteristic of social reality/capitalism—onto his subjects' consciousness in so seamless a manner as to lose all sense of the causalities inherent in their relationship. Although he could never discount a thoroughfare between the two, it is the lack of any hint of mediating logic, and thus a precise sense of *who* exactly his subjects are; where they have come from; and where they are going that he criticises:

The modern literary schools of the imperialist era, from Naturalism to Surrealism, which have followed each other in such swift succession, all have one feature in common. They all take reality

9 Lukács, Georg, "Realism in the Balance", *Aesthetics and Politics*, translation editor Ronald Taylor, London, Verso, 1990, p. 31.

10 Lukács, *Aesthetics*, p. 32.

11 Lukács, *Aesthetics*, p. 32.

opposite
Gregory Green. *Gregnik (Proto 1)*, erection of satellite on roof of Gateshead Technical College (broadcast site), Tyne and Wear, 1996. Photo: Simon Herbert.

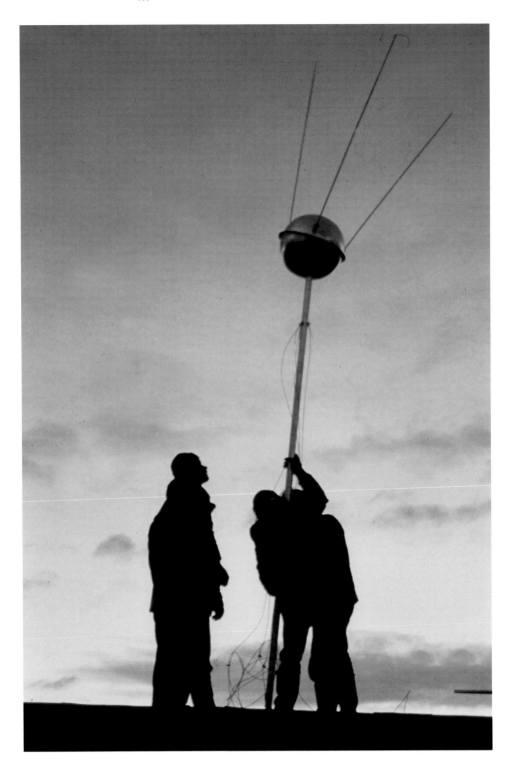

exactly as it manifests itself to the writer and the character he creates...both emotionally and intellectually, they all remain frozen in their own immediacy; they fail to pierce the surface to discover the underlying essence, i.e. the real factors that relate their experiences to the hidden social forces that produce them.[12]

12 Lukács, *Aesthetics*, pp. 36 and 37.

With ever greater force, and despite his protestations to the contrary ("ontologism" is in fact what he accuses all and sundry treacherous immediatists of) one gets a sense of the contradictory position of ontological security from which Lukács's tracts were written. Never is there an echo within his analytical or philosophical method itself—a process he naturally regards as "objective"—of the transformative drama he sees modernity (and all those things which act as ciphers for it) unleash within aesthetics. This means that, for all his focus on art and aesthetics, he cannot leverage for art any significant new role as a category of knowledge. Theodor Adorno's later rejoinder, which picks apart Lukács's main argumentative strands on realist literature, attempts to show how Lukács fails on his own terms and on both self-declared crucial issues—of knowledge and subjectivity—by not taking his dictums to their logical conclusion:

Lukács places himself in the great philosophical tradition that conceives of art as knowledge which has assumed concrete shape, rather than as something irrational to be contrasted with science. This is perfectly legitimate, but he still finds himself ensnared in the same cult of immediacy of which he myopically accuses modernist literature: the fallacy of mere assertion. Art does not provide knowledge of reality by reflecting it photographically or 'from a particular perspective' but by revealing whatever is veiled by the empirical form assumed by reality, and this is possibly only by virtue of art's own autonomous status. Even the suggestion that the world is unknowable, which Lukács so indefatigably castigates in writers like Eliot or Joyce, can become a moment of knowledge... The essential distinction between artistic and scientific knowledge... is that in art nothing empirical survives unchanged; the empirical facts only acquire objective meaning when they are completely fused with the subjective intention.[13]

13 Adorno, *Aesthetics*, pp. 162 and 163.

For these precedents to have any bearing on contemporary discussions of realism, one must however take into account the exploding array of representational, interpretative and imaging technologies, which have emerged since the first half of this century. This not merely for the new representational modes they have brought into being, but for the impact they have had on lived experience and that all-important "subjectivity". To a greater or lesser degree cybernetic structures (and among these I would classify those affiliated with storage media such as video and tape, as well as the countless prosthetic and computer technologies) alter human consciousness: the liberal subject who is, still, so strongly present—speaking and being spoken of—in all of this socialist friendly fire has been fractured, ensnared—but also enhanced and empowered—by mechanisms more literally "in touch" with her than anything in the chaotic media environment these critics already regarded as so quintessentially modern.[14] This is not to say that these systems do not

14 For an excellent overview of the historical development of cybernetic systems, see N. Katherine Hayles, *How We Became Post-Human: Virtual Bodies in Cybernetics, Literature and Informatics*, Chicago: The University of Chicago Press, 1999.

have antecedents in earlier centuries or that they are wholly twentieth-century inventions; rather that their integration into human mental and corporeal activities and thus also into the human self-image was intensified and complexified at an unparalleled rate during this period. Lastly, although the aesthetic and philosophical definition of the term realism—the former that of fidelity of representation and truth to nature; the latter that of ideas or matter having objective existence—have long been paired in a vibrant dance of mutual parasitism, the emergence and tightening of these cybernetic feedback systems means that their interdependence has increased all the more.

In this context, Green and Hesse-Honegger operate with a certain wilful obstinacy. Flirting with historical naiveté, they deliberately ignore post-modernist critiques of objectivity and their attack on epistemological systems that make recourse to any kind of truth or concomitant understanding of the real (one might speculate that these critiques' troubled alliance to, rather than their predetermination by, the above cybernetic structures seems of greater interest). Instead, both artists borrow from the methodologies of scientific research, inventorisation and documentary, all of which are themselves redolent with scientific normativity. In this their approach is reminiscent of a tendency within the work of many artists who have grappled with the representation of nuclear power and war. This tendency, which one might identify as realist, hyperrealist, didactic or deconstructive, but which always focuses on the minutiae of the nuclear context (its factories, bombs, employees and socio-cultural traces) rather than the nuclear event itself, seems to have grown in response to two distinct factors. One is the existence of certain absolute human representational limits—the primary one being that of nuclear destruction itself (or, more abstractly, human extinction)—and the second, which is necessarily more erratic in its manifestations, the desire to harness the undeniable semiotic power of renditions of its base (photographs, replicas, scientific illustrations, found objects, itineraries, first person accounts—alternatively didactic and demystifying but nonetheless all ideologically inflected).

At Work in the Fields of the Bomb by Robert Del Tredici is exemplary of this tendency.[15] In his own words "aiming to close the gap between our icons and reality in the matter of these weapons" this book (again) collates photographs, interviews, diagrams and texts relating to the nuclear age and especially the destruction wrought by the bombs on Hiroshima and Nagasaki. Framed as an autodidact's exploration into the awe-inspiring and mysterious destroyers we find in our midst, the book opens with the following words: "*At Work in the Fields of the Bomb* began the day it dawned on me I'd never seen an H-bomb factory. I knew that nuclear weapons didn't grow on trees, but I couldn't tell you how they did grow."[16] Later in the preface Del Tredici states:

15 Del Tredici, Robert, *At Work in the Fields of the Bomb*, London: HARRAP Ltd., 1987.

16 Del Tredici, *Bomb*, ix.

> I finished the project while it was still possible—through the eyes of living witnesses—to see back to day one of the nuclear age. More than once in my encounters with atomic pioneers and on expeditions to America's ageing bomb factories I felt I was coming from some future time-machine back to that legendary era when nuclear weapons ruled the earth.

This project is infused, as Green's and Hesse-Honegger's are, with a sense of individual empowerment. As a totem of everyman's capacity to unmask the face that the powers that be present to him/her, or to perform an act of political archaeology, it could hardly be bettered. Like that popular life-manual *Zen and the Art of Motorcycle Maintenance* by Robert M. Pirsig, it is also infused with the liberal sensibility of the late 1960s and 1970s—a can-do optimism regarding the individual's power to understand political reality using interpretative tools directly at his/her disposal. At a stretch, one could call the book a photographic journalists' response to one of the rhetorical devices of Pirsig's book, namely the "Aristotelian" philosophy of material deconstruction (crudely put and carrying over from the book its subtle misapprehensions of the two central philosophical paradigms, this Aristotelian philosophy believes reality can be understood by breaking it down into parts and knowing it physically—illustrated by the subject's ceaseless taking apart and putting together of his motorcycle and his railing against "Platonic" car drivers who he perceives as merely consuming a distant, framed and shadowy reality through their windows). Pirsig's subject believes reality can be known and we can equip ourselves to know it; Del Tredici too believes we are better equipped than we think to not only understand nuclear technology but thus also to act upon that understanding. Importantly, understanding brought about by *seeing*—photographs— plays as big, if not a larger part than understanding brought about by reading—interviews and policy texts. The uncanny similarity to Green's methodology and resulting *objets instructifs* is perhaps best illustrated by a photograph of Howard Morland holding his model of a modern H-Bomb warhead (Washington, D.C. July 10, 1983). This warhead is carried by MX, Trident, Minuteman and Cruise Missiles and capable of producing an explosion 20 times more powerful than the Hiroshima bomb. Morland stands on the steps of a governmental building fronted by Athenian-style pillars as if to challenge the authority they signify with the mere fact of the model's construction. The caption reads:

> ... Howard Morland was the first to make visible to the public the inner workings of the H-Bomb. He pieced together its physics and internal design from unclassified literature and conversations with industry and government officials. In 1979 the U.S. government sued to prevent the publication of his article "The H-bomb Secret (To Know How Is to Ask Why)" in *The Progressive*. Morland welcomed the lawsuit, maintaining that there are no longer any scientific secrets about H-bomb design. In court he demonstrated the public nature of his data, won the case, and published his article.[17]

17 Del Tredici, *Bomb*, p. 129.

As stated before, whether it is Hesse-Honegger, Green or Del Tredici their aesthetic procedures are defined as much by their *incapacity* to make certain things visible as it is by their capacity to do so. This is movingly characterised by Del Tredici's interview with Yoshito Matsushige, survivor of the Hiroshima bombing and a photographer who attempted to document the destruction for his local Hiroshima newspaper, *Chugoku Shimbun*. Although Matsushige did photograph some scenes, believing it to be his obligation as a photographer, he also describes several others which left him paralysed: at the heart of the destruction, and forewarning the debates that were subsequently

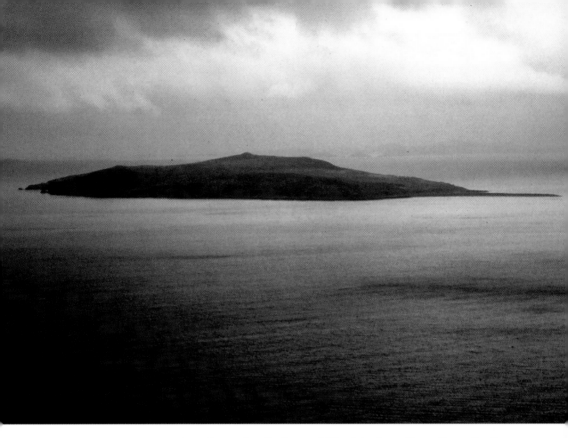

conducted regarding the impossibility of dealing with another extinction —the Holocaust—on *any* level of aesthetics, photographic representation reaches its limit. In one of these scenes, a swimming pool's entire water content had evaporated: "it must have been almost boiling, and the people couldn't get back out of the pool, so they died in the hot water. There were seven or eight people like boiled fish at the bottom of this pool." Another, of a damaged streetcar jammed with people which had found itself near the epicentre of the explosion, finally incapacitated the photographer:

> They were all in normal positions, holding onto streetcar straps, sitting down or standing still, just the way they would have been before the bomb went off. Except that all of them were leaning in the same direction—away from the centre of the blast. And they were all burned black, a reddish black, and they were stiff... They had all died instantly... I put my finger on the shutter for one or two minutes, but I could not push it. I refrained from taking the picture. It was too terrible to take a picture of.[18]

18 Del Tredici, *Bomb*, p. 189.

The precedents of the above conversation about realism run back along the course of the Western philosophical tradition—and Pirsig's *Zen and the Art of Motorcycle Maintenance*, which narrates the lone bike rider's Platonic-Aristotelian journey allegorically—is indeed structured around an open acknowledgement of this fact. The story has however been made infinitely more complicated than this book and its metaphors allow. Twinned, the logic of deterrence and modern imaging and

above
Gruinard Island, Scotland, 1998.
Photo: Jon Bewley.

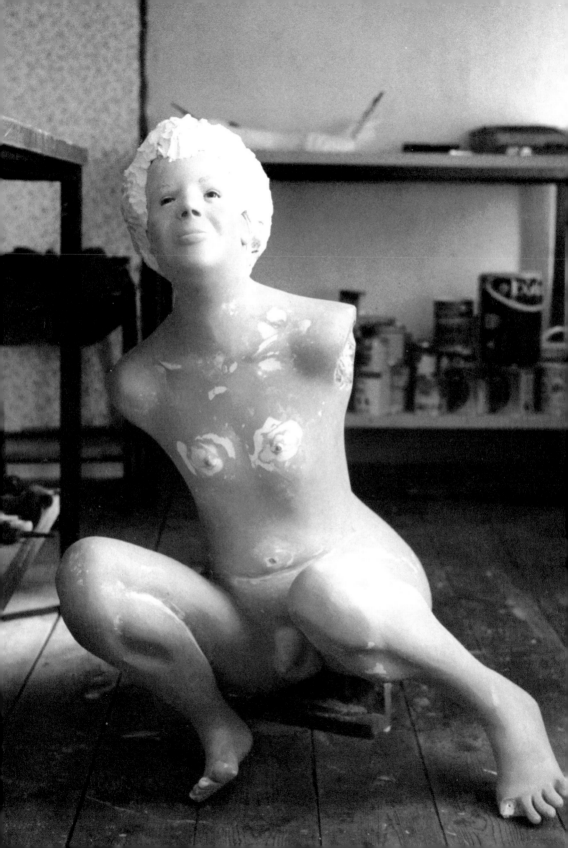

opposite
n, prototype sculpture work-in-progress in the artists' studio, 1999. Photo & © Lloyd Gibson.

simulation technologies have created an arguably unbeatable, and certainly unrepresentable, virtuality. In considering what Del Tredici calls "the invisibility" of the nuclear bomb, it is impossible to escape the strange, Hydra-like simulacra that draw us away from its physical reality. Judging by the degree of political inaction, not even nuclear warfare and energy's most conspicuously negative, or destructive, emanations—the ecological and human disasters that pile up, decade by decade—are a match for these conceptual black holes (and being conveyed the truth of their existence by the same simulacral media which make us doubt the truth in so many other matters has no small part to play in this tug of war). The spatio-temporal enormity of this virtual world makes a mockery of the clumsiness, the pathetic garage-technology clunkiness of "Virtual Reality" proper. Nevertheless it leaves its residues in its terminology. For what, if not the Cold War's generative rationale that war can effectively be fought in *the space of possibilities*, is replayed in the sound bytes of digital interactivity: the gardens of forking paths, the limitless choices, the labyrinthine infinity. Here, in a strange and fanciful reversal of fortune, it is not the history of narrative or architecture, or even the military apparatus itself that precedes epistemologies of virtual reality and non-linear media, but rather the history of Western nuclear doctrine.

Of all those who have analysed the spatial, temporal and technological overlays at play in the global virtual predicament, it is Jean Baudrillard who has left us with the most (in)famous essays on the subject. Perhaps the most definitive of these—together referred to as "The Gulf War did not take place", were published in *Libération* preceding, during and after the hostilities of the war. Cultural Theory has already played host to endless discussions on Baudrillard's thesis, most of them centred on the cul-de-sac of his negative claims regarding the "reality" of this war and his arguable irresponsibility as a Western intellectual. But, since he did not intend to question the fact that Iraqis were attacked, nor that they suffered grievous injuries, injustices and deaths, but rather whether the war *was* a war in the accepted sense of that term (i.e. where the opponents are engaged in combat as equals) or rather an act of domination planned, predicted, completed and achieved *a priori*, and using a set of representational and simulational technologies which ensured this end, it remains an important series of articles. Quite aside from the Western cultural and militaristic imperative it analyses, it is so for its analysis of images. Baudrillard balks at the shock and horror that routinely met Hussein's use of image media. He ridicules "pious" image consumers for thinking there is such a thing as using, and making images in a just, right, true, trusted or non-perverted way. He commends Hussein, at the very least, for understanding the profound immorality of images:

19 Baudrillard, Jean, "The Gulf War: is it really taking place", *The Gulf War did not take place*, translated and introduced by Paul Patton, Sydney: Power Publications, 1995, p. 47.

> We may regret this, but given the principle of simulation which governs all information, even the most pious and objective, and given the structural unreality of images and their proud indifference to the truth, these cynics alone are right about information when they employ it as an unconditional simulacrum. We believe that they immorally pervert images. Not so. They alone are conscious of the profound immorality of images.[19]

Baudrillard believes we will never know, possess or have access to the true picture of a given situation and that desiring it only leaves us more open to the manipulations of those who have already understood the profound immorality of images and simulation. Thus:

> Resist the probability of any image or information whatever. Be more virtual than the events themselves, do not seek to re-establish the truth, we do not have the means, but do not be duped, and to that end re-immerse the war and all information in the virtuality from whence they come. Turn deterrence back against itself. Be meteorologically sensitive to stupidity.[20]

20 Baudrillard, *War*, pp. 66 and 67.

Although it is tempting to deduce from this Baudrillard's attempt at a Reality Putsch or even Cartoon Network-style update of nihilism by dint of some absolute theory of iconic equivalence, what he is instead arguing for is a more precise, perverse and appropriate game of iconic tricksterhood in which image-makers never presume that their images' meaning or ethical value is static or can ever be taken for granted.

BACK TO THE FUTURE

The semiology of the image cannot be disengaged from an analysis of oral communication and the role of ritual and myth-making. Artist Lloyd Gibson and cultural historian Mark Little understand this, much as security agencies and others whose existences depend on employing every nook and cranny of cultural transmission systems do. Gibson and Little's installation project *n*, named after a secret Ministry Of Defence experiment conducted during World War II in which anthrax was exploded over Gruinard Island off the North West coast of Scotland, will attempt to feed—and feed off—these fecund systems. By creating a life-size classical sculpture of a child on the island using Shape Memory Alloys (materials which have molecular memories at predetermined temperatures and thus enable the artists to construct a sculpture which will, depending on ambient temperatures, "remember", "forget", lose and regain the shape it was originally given) but restricting public access to it, they are adapting the kind of strategies used by government and security agencies for their own restricted sites. Although the sculpture will not vaingloriously depict a diseased body or any other figure symbolic of contamination (it merely depicts a child, crouching like an animal on the ground), its susceptibility to temperature and never-stable state coupled with its creators' deft use of secrecy, media exposure and word of mouth will nonetheless form an eerie parallel to the way the existence of other dangerous, "infected" sites is communicated, justified and perpetuated.

The account of Thomas E. Sebeok, hired as consultant by Bechtel Group Inc. to the Human Interference Task Force, and assigned the responsibility for "reducing the likelihood of future human activities that could affect geologic high-level waste repositories", proves their strategy to be rather everyday. Sebeok was asked to prepare a report on the topic for submission to the US Nuclear Regulatory Commission, via its Department of Energy. After a lengthy deposition on the discipline of semiology, and a premonitional exposition of the mythical symbol of Pandora's Box (in which he describes why the symbol appears as

emblem of both misery and destruction) Sebeok gives this advice (which I have quoted at length to give a sense of its detail and precision):

> that information be launched and artificially passed on into the short-term and long-term future with the supplementary aid of folkloristic devices, in particular a combination of an artificially created and nurtured ritual-and-legend. The most positive aspect of such a procedure is that it need not be geographically localized, or tied to any one language-and-culture (although, clearly, when linguistic and ethnic boundaries are crossed, both the verbal component and the associated set of rites are likely to undergo changes and an attenuation of the original rationale).

> The legend-as-ritual, as now envisaged, would be tantamount to laying a "false trail", meaning that the uninitiated will be steered away from the hazardous site for reasons other than the scientific knowledge of the possibility of radiation and its implications; essentially, the reason would be accumulated superstition to shun a certain area completely.

> A ritual annually renewed would be foreseen, with the legend retold year by year (with, presumably, slight variations). The actual 'truth' would be entrusted exclusively to an—as it were—'atomic priesthood', that is, a commission of knowledgeable physicists, experts in radiation sickness, anthropologists, linguists, psychologists, semioticians, and whatever additional administrative expertise may be called for now and in the future. Membership in this elite 'priesthood' would be self-selective over time.

Sebeok soon acknowledges that this term, the "priesthood" is, "of course, merely a colourful term for a self-perpetuating, government-independent committee", but he clearly prefers it to that of "Nuclear Barons" which is already in more wide-spread use and was employed by Peter Pringle and James Spiegelman, in their book *Nuclear Barons* whose working definition was that of "an international élite of scientists, engineers, politicians, administrators and military officers who *brought atomic energy under control.*" [my italics] [21]

21 Sebeok, Thomas A, "Pandora's Box: How and Why to Communicate 10,000 Years into the Future", *On Signs*, ed., Marshall Blonsky, Baltimore: The John Hopkins University Press, 1989, p. 460.

This fallacy, that nuclear power can be brought under control is based on two concepts—subtly present in every single page of Sebeok's proposal. The first being that future societies will most likely be more technologically sophisticated than our own (naturally, Sebeok is far from alone in holding this opinion which is commonly expressed in turns of phrase like "the magic of the past is the technology of the future" and it is difficult to refute, but based on extremely partial and culturally determined interpretations of both terms). It could, at a stretch, be understood as a justification for the generation of waste as, although we may not be able to deal with it ourselves, our more sophisticated descendants might be able to. However, since nuclear weapons testing, deployment, power generation *and* storage are fallible, this inevitably brings us to the second concept, namely that the lives of future-dwellers are more important than the lives of those contemporaneous to ourselves. Clearly, we are involved in the search for a temporal

elsewhere as much as a spatial one. It seems a kind of *technological* deterrence is operative between the superpowers of distant millennia as much as a nuclear one is operative between those of global geography, the problem being that their fortuitous *ménage à deux* breaks down the minute accidents happen. And, as everyone knows—irrespective of whether they blame it on nature or blame it on technology—accidents do.

In a lecture held in 1996, the artist Gustav Metzger tentatively stated that "Art arises from the feeling and the knowledge that the line between a generative and a destructive reality is paper-thin. Metzger draws vast constellations out of natural and technological destructive forces, taking the destructive and generative power of the sun—itself akin to thousands of nuclear explosions happening concurrently—as his prototypical creative engine. He asks:

> to what extent are human beings part of this ceaseless chain of destruction? Do we absorb it; does it impinge on us; is the chemical, biological entity that is the human being penetrated by that which is so overwhelmingly the stuff of life?... Is the destructivity, so deeply embedded in us, inescapably there because it is in the entire cosmos? We absorb in the course of the development of life, of which we are a part, the bombardment that is present on the earth and in the galaxies are, are present as life evolves and evolving life inevitably absorbs such elements like milk from the mother's breast.[22] (sic.)

Without implicitly naturalising nuclear technology Stefan Gec, like Lloyd Gibson and Mark Little, already seems strangely familiar with Metzger's sentiments. In sombre acceptance of nuclear instability and a resignation to the occasional cracks that appear in the power of the "atomic priesthood", he has embarked on a project of transformation. Not that of Uranium into Plutonium, but that of their destiny—on earth. Overturning the oppressive confidence of the planned destinies nuclear material has imposed upon it by its master-owners, Gec takes the fallen lives—of nuclear submarine metal in *Trace Elements* and, by sad inversion, of the fire fighters that put out Chernobyl's blaze in his commemorative project *Natural History*—and sets them on a different course, leaving them to find new destinies and witnesses. A pale ghost of the God-like super-powers of past, present and future, Gec knows he cannot make things disappear.

Green, Lloyd Gibson and Mark Little, on the other hand, are intervening more overtly in those processes of production and mediatisation that are the oxygen of contemporary capitalism. Like Projekt Atol's *Mikrolab*, Peter Fend's Ocean Earth Organisation's ecological projects or, for that matter, the US-based group Bureau of Inverse Technology's series of BIT products, their operations run parallel to that of the corporation, governmental or non-governmental organisation at many levels, especially technological-logistical. The main difference, of course, being the organisation's *raison d'être*. Ultimately, these artists' projects avoid notions of critique, enlightenment and representation, choosing rather to "redirect" technological products (as the Bureau of Inverse Technology phrase it). Their redirection extends to unconventional,

22 Metzger, Gustav, "Earth to Galaxies: On Destruction and Destructivity", from a lecture given as part of SoFA Events series at the Glasgow Film Theatre,8 November 1996 and posted on nettime, "collaborative text filtering and cultural politics of the nets", ←http://www.nettime.org→, 18 March, 1999.

politically subversive, absurd or sometimes perverse ends, though a preconceived "mission"—a philosophical, political or economic target— is rarely vocalised or put to print. This mute quality is not a case of ethical or artistic ambiguity. Rather, it is a consequence of these artists' unwillingness to assume that their projects are utilitarian, or that their effects—social, political or psychological—can be predicted in any way. It is also manufactured in anticipation of the omnivorous workings of a culture industry which can accommodate even the most radical gesture in the bat of an eyelid. The "redirection", then, is an attempt to create turbulence in systems that otherwise gyrate around the will to power of a hegemonic, capitalist and militaristic system. To intervene in the consolidation of that ultimate militaristic feedback theorem: C^3I (CCCI), Command-Control-Communication-Intelligence. The impulse of de-individuation evident in each artist's or organisation's work (for example in Green's construction of an autonomous state, the Bureau's conserted attempts at anonymous operational procedures or, more generally, the use of fictional identities) reflects a desire to mimic, utilise, and examine the global reach of the aggregate self—be it that of the corporation, global financial institution, state or non-governmental organisation. Even though its aesthetic Doppelgängers operate, to a large degree, at the level of spectacular reality, this does not distract from their ability to syphon off power from the relationship this self has created to a massively extended, inhuman temporality; nor from its superior occupancy of global geographic space.

Today, it may seem that geography and time impose their restrictions on it, but there will always be an *elsewhere*. The US military's Vision 2010 document, which outlines the flight of American global "peace management" into outer space, is only one illustration of this fact. To what degree this programme will turn out to have been a flight of fancy, or indeed in what way the axes of time and space relate to their unspecified third—capital—will depend on how long the string between materiality and virtuality, understood in the widest sense, can be drawn out. The "knowledge"—or "information economy" that is pivotal within any definition of the New World Order—is seen by many to constitute a radical break with economies based on finite resources. As knowledge can grow algorithmically, like a Mandelbröt fractal budding and blooming further into the unexplored reaches of mathematical space, the global information economy should, in the eyes of its eulogising "visionaries", be able to auto-generate into infinity. The idea that, in the final analysis, this economy is based on any less finite resources than those that preceded it (however far abstracted into the structures of the information society they may be) goes to the heart of the parasitic relationship of the two—aesthetic-representational and philosophical— definitions of realism. It shows that, like Lukács' illuminating crash, it is precisely at those points when "category errors" become uncontainable; when they threaten to bring their respective classificatory systems down, that those systems speak as truly of their own nature as any system can. Art which seeks to bring on these moments of incommensurability forcefully demonstrates the brittle relationship these systems of empirical explication have to the common-sense "reality" they so assuredly use to prop up and justify their own operating principles.

HALF LIFE

WORKS BY STEFAN GEC

ANDREW PATRIZIO

There are seemingly more people moving around our planet today than at all periods in human history put together. These people are politicians, international delegates, sportsmen and women, journalists, tourists, immigrants, refugees and artists. Such a list does not hide the fact, though, that the groups travelling the world are doing so under widely differing circumstances, with varying economic means and with greater or lesser bureaucratic obstacles put in their way. For First World travellers, such as the multinational business community or seasonal holidaymakers, the route from A (home) to B (destination) is secure and familiar, as are the conditions at the point of arrival. So when things go wrong—for example, when tourists arrive at an unbuilt hotel or, much worse, when they become caught in a confrontation between the local army and terrorists—blame can be easily assigned, to lax tour operators, the instability of proper authority 'out there' or whatever. By contrast, forced travel undertaken by political or economic refugees fleeing internal conflict in home villages is a different phenomenon on all levels. Those who travel in this way do so under duress, leaving most of their belongings behind and, above all, have no real destination. They leave but they do not yet arrive. Their mobility is also curtailed by policed borders, international law and the willingness or otherwise of politicians elsewhere to allow influxes of those from outside into the social and cultural fabric of the host. Britain currently has boatloads of refugees from Eastern Europe moored on its coastlines who are being neither forcibly repatriated nor allowed in.

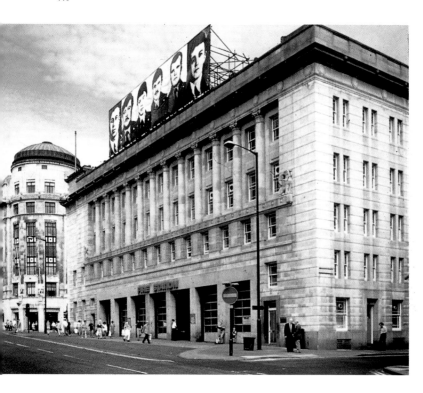

Yet this characterisation of the various forms of contemporary travel is too sweeping. While it has stimulated much interesting work in the last thirty years, we need a picture that is more complex and nuanced.

For a start, existence of clearly defined communities, be they based on ethnic origin, sexuality or religious belief, are pretty much impossible to find in isolation and are not as closed, bounded and authentically pure as might be imagined. Similarly, such communities do not function in a fixed geographic place. People create communities for themselves and through their own social interactions person to person, family to family or group to group. Social space is not a physical thing out there waiting to be carved up—a sculptural metaphor—but is formed out of myriad points of contact, collaborations and exchanges. Choose a particular area—Peckham in south London, where Stefan Gec lives—and it is clear that its unique identity is not contained within its administrative borders alone, nor in its buildings, nor its racial mix, nor the kind of food or drink one can buy on its streets. Nor does it have an identity solely in opposition to East Dulwich, to take one nearby neighbourhood. Rather Peckham, just like anywhere else, is a name of convenience, a porous and changing system, or series of systems, bound together along certain lines of power and organisation which, however strong, will break down and alter over time. This breakage, alteration and subsequent reformation happens because of the interactions that inevitably take place in the course of living out our lives in social space. Gec talks with fascination today about the social visibility of ethnic Albanians and Slavs who have found themselves on Peckham High

above
Natural History, Firestation, Newcastle upon Tyne, 1995.
Photo: John Kippin.

opposite
Stefan Gec, *Natural History*, Ukrainian Cultural Centre, Winnipeg, 1998.
Photo: Jon Bewley.

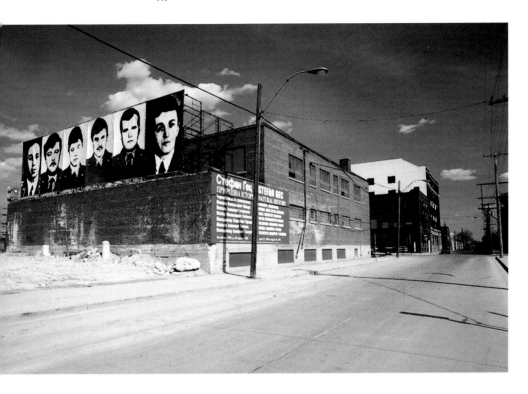

Road, somewhat lost and naïve in comparison to the British Caribbean and African communities for whom London is home, as it has been for years. The fact is that we are starting to think more about the processual and ongoing dynamic that moves everything along, inevitably yet indeterminately, and less about static artifacts and end products from bounded territories. Similarly, the creation of ethnically pure pasts can be seen to be little more than holding operations by power groups seeking to establish an exclusion zone of authenticity and lineage against corruption from outside. And whether that is viewed benignly, as with the support for Maori's in New Zealand, for example, or negatively, as in the groupings of white farmers in South Africa, depends on how one views the operation of power within that context. Our notion of 'community' can be sympathetically filmed in soft focus or savagely reinforced by violence.

After spending eight years working in an unskilled textile mill job, it took Gec only a matter of weeks into his art foundation course at Huddersfield Polytechnic to start, for the first time, to explore his Ukrainian background through art. This began with modest etchings but, with his confidence in this line of enquiry validated by tutors at Newcastle upon Tyne Polytechnic, where he went on to do his degree, it has become the engine of his subsequent creativity. A clear parallel can be drawn here to numerous women artists and those of black, colonial origins working in Britain from the 1970s onwards who drew on equally personal elements in the construction of their own identity. For Gec it was his incomplete and vague knowledge of his father's homeland which

spurred further enquiry and he admits that his father may well have ignited his own curiosity had he bombarded him with stories from the East. Instead, relative silence allowed multiple narratives and possibilities to grow in his own mind, a characteristic that the artist now feels is important in a wider context: artworks and their explanation should never offer everything immediately but through fragmentary revelation become increasingly powerful over time.

Gec's venture into his Ukrainian lineage was motivated in part by his feelings of insecurity in an orthodox fine art educational system and by genuine curiosity concerning his own identity. Appropriately enough, 'Ukraine' roughly translates as 'borderland', lying as it does to the far west of Russia and most of her other 'Republics'. (It is impossible to write of this region without being aware that borders are being redrawn monthly, with names and statues toppling in the light of that redrawing.) Ukraine along with Belarus is ethnically east Slav and has passed under the control of Lithuania and Poland, and their Roman Catholic ruling classes. More romantically, it is the original Cossack country. After the Second World War, millions died as a result of Stalin's agricultural collectivisation. Many more were to be killed by invading German troops, and after the War in widespread purges of Nazi collaborators. But just prior to that, and due to the drive east by Hitler, Gec's grandparents fled their homeland. His father's eventual arrival as a boy in the late 1940s, first to Lincoln then to Huddersfield, where many other Ukrainians struck roots, clearly marks out him and his family as reluctant refugees. And it makes it easy to understand his son's emotional identification with Albanians wandering the streets of south London sixty years later, having drifted in from 'somewhere else'.

The human fall-out of which Gec senior was a tiny particle was a consequence of the Second World War, an explosive event that dispersed populations across Europe and the Americas. Similarly today's Albanians and Slavs are here in Britain following the violent re-opening up of ethnic divisions which had festered beneath arbitrary nationalities imposed on them throughout this century. In this context we can appreciate the emotional as well as poetic impact on Gec when, at 1.24am on Saturday 26 April 1986, Block 4 of the Chernobyl nuclear plant in the Ukraine exploded following a botched shutdown procedure.

Ten years before Chernobyl was built, in the 1970s, the travel writer Laurens van der Post had visited the region around Kiev, the capital of the Ukraine. It is impossible not to read into his words an anticipation of its catastrophic future:

> I caught my first real glimpse of chernozem, the famous black earth of Russia, on the way from Rostov to Kharkov... I have never seen more profoundly exciting earth. Even its blackness was not the colour of negation but of the mystery of the great power of growth and rejuvenation with which it is charged. On that day the sky was packed with storm clouds, and the lack of luster and light should have made the earth darker. Instead it had a sheen upon it as the glint on a raven's wings, and where a shower of rain had left moisture, it had a positive midnight brilliance... The horizon itself

was a perfect circle, as if nothing but the expanding circumference of a ripple started by a pebble in a dark pool, in which we were condemned forever to be at the center.[1]

1 van der Post, Laurens, *A Portrait of all the Russias*, London: Hogarth Press, 1967, pp. 98 and 99.

Unknown to Gec at the time, his cousin Olga was by chance in Chernobyl when the plant exploded—the centre of the dark pool—and has since become seriously ill through exposure to radiation. A later passage in the book by van der Post again seems prescient despite the finger-wagging tone:

The Soviet Union is at the merest beginnings of its industrial development, vast as that beginning already is. What will happen to the land in the process, what price will be paid in the values and meaning of life—these are other matters. Superstitions of the mind and spirit are bad enough, but the superstition about matter and machines which the Soviet State is putting in their place is, I believe, more deadly.[2]

2 van der Post, *Russias*, p.106.

Gec's first work in relation to Chernobyl was a performance called *Bitter Waters*, undertaken on the fourth anniversary of the accident in 1990. He separately washed two fleeces, one from Cumbria, one from Northumbria, in a reservoir that bordered the two counties and was acknowledged to be contaminated by Chernobyl fallout. The wool was woven into two panels and joined in the centre by a length of embroidery from the Ukraine. On one level, the work alludes to the untraceable boundary between what might be considered the 'centre' and the 'periphery'. Clouds into which the immediate radioactive material was thrown carried the most toxic elements away from the disaster zone and broadcast it first into Scandinavia, then Britain, Central Europe and the Balkans (though changing weather conditions meant that virtually all of Europe was affected). *Bitter Waters*, as with the following Locus+ commission *Natural History*, demonstrates on many levels how climate and catastrophe might combine in ways that defy and confuse national boundaries. Gec's somewhat haphazard family history which created a route from the Ukraine to the north east of England was re-traced decades later by the poisonous caesium-137 which, equally haphazardly, followed in the rain clouds. Indeed it was

From left to right:
Stefan Gec, *Trace Elements*, 1990,
Whiskey Class Submarines at Blyth.
Photo: Richard Mahoney.
Casting steel from submarines.
Photo: Simon Herbert.
Foundry workers and Stefan Gec (second from left) with bells, Guisbrough, North Yorkshire.
Photo: Steve Collins.
Installed High Level Bridge, Newcastle upon Tyne.
Photo: Simon Herbert.

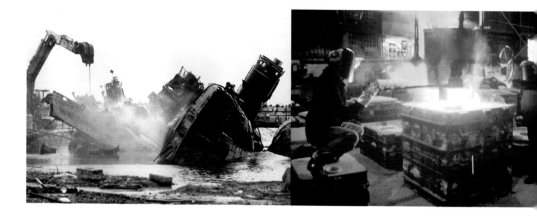

rainfall which brought the radioactive material to earth which, when eaten by sheep, proved to be the most effective vehicle in transmitting contamination into the human food chain; hence Gec's combined use of sheep fleece and water. At the time, the Western media attempted to 'contain' this disaster through the perception that we were merely witnessing the old Soviet Bloc nuclear industry cracking, a sign of much wider obsolescence. Such neglect and negligence would simply never happen here. Inevitably, the Chernobyl disaster saw both political and national agendas being played out, but it also witnessed more subtle ones, which speak of the porous and temporary boundaries that inscribe our lives wherever we might live on this planet.

These are the issues that lie below the surface of the major project inspired by Chernobyl, *Natural History* (1995). It was installed at Pilgrim Street Fire Station, Newcastle on the ninth anniversary of the disaster, and just four months before Gec made his first visit to his father's homeland. Gec became aware through a Tyne-Tees news report that a delegation from the Chernobyl and Pripyat fire-brigades, who heroically stopped the plant fires overnight but suffered worst from radiation poisoning, were repaying a visit made to the Ukraine immediately after the event by firemen from Newcastle. Researching the event, Gec came across small portrait photographs of the first six firemen killed in the immediate aftermath of the fire. These images, of course, soon became buried in the popular conscience as the impact of Chernobyl dissipated, like the radioactive particles themselves. By reprinting them and publicly displaying them on top of the fire station as 4.5 x 3 metre scanachrome photographs, that is of similar proportions to banners which in old Soviet countries political leaders were paraded through the streets, Gec sought to re-instate the prominence of those six firemen, namely Nikolai Vasilievich Vashchuk, Vasilii Ivanovich Ignatenko, Victor Nikolaevich Kibenok, Vladimir Pavlovich Pravik, Nikolai Ivanovich Titenok and Vladimir Ivanovich Tishchura.

Given that Gec's art is concerned with conditions of movement and change as they manifest themselves, he clearly understands that those projects of his which have been installed in other countries unavoidably alter their meaning. Due to the mimicking of conventional depictions of

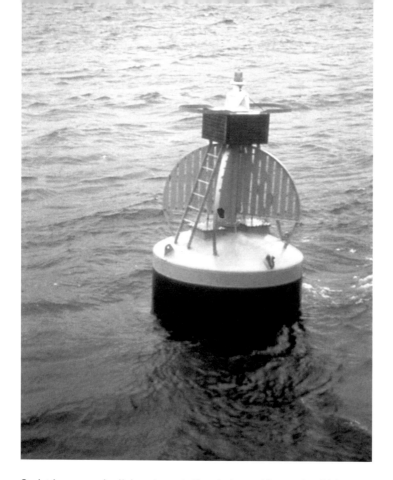

Soviet heroes and religious icons in the photographic panels which make up *Natural History*, its siting outside the Ukrainian Cultural and Education Center in Winnipeg, Canada was received uncomfortably by some among the large ex-patriate population who live there today. In the 1960s the Artists' Placement Group in Britain adopted the useful, if arithmetically arbitrary, equation that 'the context is half the work', and certainly we might see Gec's work as illustrative of how contextual changes amend or reposition meaning. Whilst all artists have no more than partial control over many of the contextual factors bearing down on their work, Gec is one who makes work in the explicit knowledge that meaning relates both to the geographic and psychological positioning of art.

These issues are central to Gec's most ambitious project, *Buoy* (1995, and ongoing), which was itself preceded by two related works, *Trace Elements* (Newcastle, 1990) and *Detached Bell Tower* (Glasgow, 1994, Helsinki and Derry, 1995). The two earlier works began with the discovery in 1990 that eight Soviet Whisky Class submarines were being scrapped at a long-standing decommissioning yard—Battleship Wharf—in Blyth, just north of Newcastle. The artist intercepted and arranged for eight large bells to be cast from salvaged steel which were then suspended at water level from the High Level Bridge above the Tyne in Newcastle. At low tide they were visible; at high tide they were

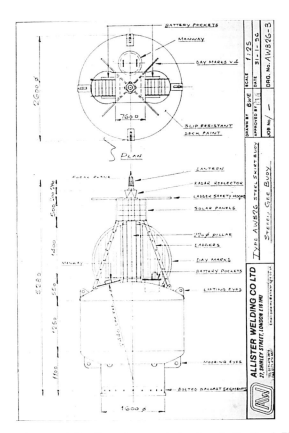

submerged. For the subsequent showings in Scotland, Finland and
Northern Ireland, the bells were tethered to beams and suspended from
low roofs, where they remained visible at all times.

There are a number transformations brought to our attention in *Trace
Elements*, *Detached Bell Tower* and *Buoy*. Firstly a historic/political
one—during the Cold War, these submarines represented to the
Western mind a dark, hidden and remote threat beneath the waves. By
contrast, for those Soviets who worked on them (and co-incidentally,
Gec later learned that another of his Ukrainian cousins was one such)
they were a temporary home and a job. For submariner families
stationed in ports such as Murmansk, on the Barents Sea, they were
vulnerable repositories for loved ones. But that was then. In the early
1990s the empty submarine carcasses, lying rusted and beached in the
Blyth docks, were a fairly obvious sign for the dismantled and
fragmenting Soviet Bloc. In choosing to cast the hull metal into bells,
the artist points to ritual and religion (the re-emergence of the Orthodox
Church in Russia followed immediately after the crisis of 1989) as well
as more poetic associations concerning long-distance communication,
and the faculty of hearing over that of sight. The eight bells were then
installed into a fully operational buoy in 1996 and launched in June of
that year in Hartlepool to become *Buoy*, a project whose completion is
still to be determined. What is clear, however, is that the locations that

opposite
Stefan Gec, *Buoy*, in Belfast
Lough
© Ormeau Baths, Belfast

above
Technical Drawing

have been, and will be found, for *Buoy*, such as near Derry, Rotterdam, Reykjavik, Harwich, Copenhagen, Oslo, Stockholm, Riga, St. Petersburg and finally Murmansk (where the submarines started their commissions) all retrace the routes of the Cold War submarines. The sites for *Buoy* purposefully re-mark the old and redundant co-ordinates that once governed surreptitious movement underwater.

Gec has spoken of wanting to place *Buoy* in the present, whilst acknowledging its past. After the object spent almost two years marking, as all buoys do, the edges of shipping lanes, dangerous marine objects and the entrance to safe harbours (each powerfully ironic functions considering the origin of the metal bells), Gec altered the work by deciding to place advanced recording equipment on board. *Buoy* would now be transformed into a state-of-the-art marine weather station. The surveillance of malevolence has been recast as benevolent. Shortly, the artist will start working with the authorities to place *Buoy* in the experimental zone to begin tests, then its voyage will continue.

As with *Natural History*, *Buoy* is accruing different meanings with each repositioning. It is at once the marker of a shipping lane, yet an acknowledged 'sculpture' in the broadest possible sense at the same time; it is a brief memory for a sea captain who passes it in the North Sea, as well as an anecdotal point of contact for friends and helpers of the artist who wonder where it now lies. More than anything though it acts as a symbolic marker for the two-way passages that lie between things, the mapped out abstractions that connect countries, communities or individuals with each other—trade routes, if you like, on a psycho-geographic plane. The linkages, the geometries of power, may be invisible on the surface but exist nevertheless and *Buoy* is not so much an 'artwork' or 'end product' as a series of activities, undertaken by the artist, his commissioners and collaborators and others who come into contact with it (physically or mentally) that illuminate something about how our world actually works. The history, which is embedded in the metal almost alchemically, cannot be extracted or removed. That which can be said of *Buoy* can also be said of *Natural History* or its predecessor *Bitter Waters*—physical as well as conceptual elements within the work may dissipate and spread with each transformation, but nothing truly disappears. The processes of submersion and dredging up take place all the time, without end. Gec's work participates knowingly in these processes.

Perhaps a new type of art is becoming possible; one which adopts and develops some of the rethinking which is taking place in other disciplines, particularly geography and other social sciences. Expanding further the already broad definition of what a contemporary sculptor might be, it is becoming possible for some practitioners to create objects that operate in the world distinctly differently from conventional sculpture and installation art. These objects, rather than generating ideas directly through the visual, activate the space between things and highlight social integration, change and exchange as facts. Yet this is surely not a social science, but a poetic and abstract occupation, which weaves its way through the fabric of our political, economic and demographic lives.

opposite
Stefan Gec, *Buoy*.
Maritime Museum,
Hartlepool. 1996.
Photo: Jon Bewley.

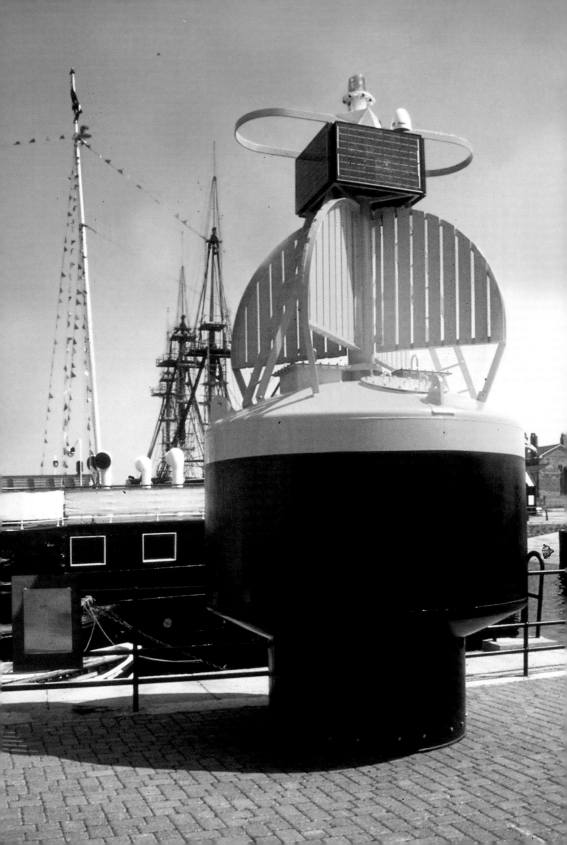

AN AESTHETICS OF DISSENT

CORNELIA HESSE-HONEGGER

PETER SUCHIN

"We have only begun to discover the benefits of seeing science and art as one." Thomas S Kuhn [1]

1 Kuhn, Thomas S, *The Essential Tension*, Chicago: University of Chicago Press, 1977, p. 343.

The work of Cornelia Hesse-Honegger exists at a point between conventional classifications. It occupies a solitary place. From the perspective of the orthodox scientific community Hesse-Honegger's paintings display, despite their obvious debt to careful observation, the subjective, and thus "unscientific" measure of the artist. In reading these images of wildly mutated insects as "art", science finds easy ammunition for a refutation of their implicit claim as factual records of gross disturbances within nature, the received idea of the artist being of one concerned not with the real but with fantasy or exaggeration. Hesse-Honegger, one speculates, must appear to be, from the purview of mainstream science, something of a traitor to the illustrative task at hand, having supposedly abandoned the objective (and thus verifiable) recording of nature for a semi-surreal painterly practice steeped in esoteric invention. And even when scientists accept the accuracy of the paintings they nevertheless dispute their most important implications. Science wants repetition; it demands it as proof of the state of things "out there", outside and beyond individual opinion and the maverick gathering of "facts". Hesse-Honegger's paintings are, essentially, renditions of discrete creatures whose idiosyncratic deformities pose the problem of repetition and environmental effects in a manner science refuses to accept as meaningful. In the mutations of numerous single insects Hesse-Honegger's practice does however point to an objectively measurable order of distortion. Even if no two creatures' deformities display a parity of genetic corruption, the overall picture revealed is one of widespread environmental damage. No matter that the anomalies found within individual insects don't neatly map one onto the other: the multiple number of mutations observed should furnish sufficient and convincing evidence of a crucial, far-reaching rupture within the natural pattern of nature.

But if the scientific community refuses to see these paintings as acceptably objective, their status as art is also problematic. Hesse-Honegger trained as a scientific illustrator, and it might easily be claimed that illustration is not "art" but rather mere technique, a formulaic manner of record-making largely devoid of the innovative, critical and transformatory qualities frequently associated with artistic production. (Paradoxically, it is this very reading of illustration as literal and direct that should support the pictures' acceptance within the scientific field.) For one audience Hesse-Honegger's practice is invalidated by its artistic contingencies, for another it is simply not artistic enough. The pictures' execution within the ambiguous medium of watercolour further complicates their classification. Watercolour painting is not a controversial form of address; it might even be said to be a more than conservative medium, particularly when contrasted with the various photography-based media increasingly utilised today. Yet it is precisely this distance from the authority currently invested in photographic and electronic technology that gives Hesse-Honegger's pictures their critical edge. There is something unnerving about seeing the miniscule monsters Hesse-Honegger depicts rendered in what Brian Eno has described as "that curious medium which seems to stand on the borderline between "Sunday painting" and "serious painting"." The format of watercolour, Eno continues:

> ...does not stipulate a particular emotional range, and presents itself to a perceiver in a kind of innocent and understated way... It seems that at a time when the currency of the day is to engage in productions that are in some way epic... that which is simple and quiet suddenly becomes especially relevant. [2]

Thus the truly disturbing implications of Hesse-Honegger's work are most appropriately conveyed through the quiet insistence of a medium that is, on the one hand, deeply distanced from the camera and the computer and, on the other, intimately bound up with painterly and illustrative traditions.

The scientific establishment normally confirms its speculative assertions through the carrying out of expensive, technically sophisticated experiments supported by high levels of both public and private funds. Those who would presume to disagree with professional science are, through their very marginality, all too easily dismissed as amateurs. There is, however, much to defend the practice of the amateur, particularly at a time when the production of knowledge is rigidly formalised within officially-sanctioned institutions. Hesse-Honegger's scientific training means that it is unreasonable to dismiss her research as that of an inexperienced "amateur", though this is precisely what professional science tries to do. Where her work does partake of the stance of the amateur is in its challenge to establishment science. "The amateur's principal purpose", suggests R. H. Stephenson, "is to... evaluate, to the best of his ability, the results arrived at by professional practitioners." [3] The detective work involved in Hesse-Honegger's vigorous critique of institutionalised truth puts us in mind of that much admired if fictitious figure, Sherlock Holmes, whose unconventional methodologies invariably unearth a dissenting but

opposite
Cornelia Hesse-Honegger. *Fire bug. Pyrrhocoris apterus.* Two legs on left side are light and bent. The chitin armour is soft rather than firm. Found in Bernau, by J. Jenny, near the Leibstadt power plant, Germany, 1990.
Photo: Peter Schälchli
© Cornelia Hesse-Honegger.

2 This and the following quotation, Brian Eno, "Peter Schmidt and Brian Eno", *Arts Review*, Vol. XXIX, No. 25, 9 December, 1977, p. 737.

3 Stephenson, RH, "Last Universal Man—or Wilful Amateur?", *Goethe Revisited*, ed. Elizabeth M Wilkinson, London: John Calder, 1984, p. 56. For further discussion of the amateur see Peter Suchin, "*The Destruction of Art as an Institution: The Role of the Amateur*", *Variant*, No. 5, Summer/Autumn 1988.

pensive rendition of events. Holmes embodies the notion of the serious
amateur, someone who refuses to take at face value the allegedly
obvious. He follows his own subtle assessment of circumstance, invests
not in convention but in informed observation. In "A Case of Identity"
Holmes proposes: "Perhaps I have trained myself to see what others
overlook", surely an approach which might well be applied to Hesse-
Honegger's own vigilant investigations. [4] Holmes also observes that
"It has long been an axiom of mine that the little things are infinitely the
most important." Such attention to detail is also a necessary component
of Hesse-Honegger's astringent research. Along with Gaston Bachelard,
another perceptive critic of scientific convention, Hesse-Honegger
recognises that "the miniscule, a narrow gate, opens up an entire
world." [5] If there is, and intrinsically, a move towards the excessively
small within Hesse-Honegger's paintings this focusing in upon the
microscopic only serves to emphasise the immense threat posed to
human and other life by nuclear power.

There are several levels of aesthetic attention within Hesse-Honegger's
work. At one end of the spectrum there is that of the artist herself,
magnifying through her paintings the anomalies evident in a given
insect. Here something usually invisible is made available for inspection
by the unassisted eye. The paintings themselves are small, though the
insect observed is presented many times larger than its actual size. On

4 This and the following
quotation, Arthur Conan Doyle,
quoted in Michael and Mollie
Hardwick, *The Sherlock Holmes
Companion*, London: John
Murray, 1962, p. 154. Naomi
Schor has strongly suggested
that attention to detail in artistic
matters is an attribute closely
associated with "the feminine".
See her *Reading in Detail:
Aesthetics and the Feminine*,
London: Methuen, 1987, and the
review of this work by Peter
Suchin, *The British Journal of
Aesthetics*, Vol. 28, No. 4,
Autumn 1988.

5 Bachelard, Gaston, *The
Poetics of Space*, Boston:
Beacon Press, 1969, p. 155.

occasion the watercolours are further enlarged through photographic means in order to be reproduced on posters, in magazines, or in books (a form of image distribution which is in no way anathema to Hesse-Honegger's deliberately didactic, not to say Brechtian, practice). This photographic enlargement offers another strata of perception and response, distributing the painted image well beyond the narrow province of gallery-located art. Indeed, it is a normal function of the illustrator that he or she produces work with such mass reproduction in mind, the making of the original image being but a means to an end and not an aesthetic act in its own right.

Hesse-Honegger's watercolours have been displayed both in art galleries and in museums of science, being more than sufficiently complex enough to hold their own in either context. They raise through their varied placing questions about the limits and alignments of "science" and of "art". The dialogue between these two supposedly opposed frameworks goes back at least several centuries, as Hesse-Honegger herself points out:

> In the fifteenth century, art was 100 years ahead of science. Nowadays, that gap has almost completely closed, but I truly believe that we cannot really see something that has not been painted or put into an artistic form. It simply does not exist until then. I believe that

the artist should be incorporated into the academic world, integrated into the learning of every subject. [6]

These considerations foreground a role for the artist that is neither decorative nor supplementary, but fundamental. In this model of practice the artist acts to evaluate the validity of orthodox beliefs, be they scientific, religious or of any other kind. He or she is also someone who makes things visible, giving to the Bergsonian flux a stability of meaning, isolating individual elements of the physical world in order that they be available for contemplation and critique. In the present context, criticism requires a move away from prevalent representations of the real, as well as from the technologies holding this "real" in place. The invention and extension of photography has been, and remains today, a method of constructing and controlling meanings. As Jean-François Lyotard has noted:

photographic and cinematographic processes can accomplish better, faster, and with a circulation of a hundred thousand times larger than narrative or pictorial realism, the task which [nineteenth-century] academicism had assigned to realism: to preserve various consciousnesses from doubt. [7]

6 Cornelia Hesse-Honegger, quoted in Jeremy Hall, "A terrible beauty", The Independent Magazine, 30 March, 1996, p. 11. An obvious example of a Renaissance figure operating across distinct subject areas prior to their rigid demarcation is Leonardo da Vinci. The noted Leonardo scholar Martin Kemp has published a short piece on Hesse-Honegger in the 9 April, 1998 issue of Nature ("Hesse-Honegger's hand-work", Vol. 392, No. 66761.).

7 Lyotard, Jean-François, The Postmodern Condition, Manchester: Manchester University Press, 1984, p. 74. See also Lyotard's "Presenting the Unpresentable: The Sublime", Artforum, April 1982. For a further application of remarks by Lyotard to Hesse-Honegger see Peter Suchin, "Insects in Transition The Paintings of Cornelia Hesse-Honegger", Mute, No. 6, Autumn 1996.

In other words, what we take to be "the real" is not simply given or natural but is the result of a relentless, circumspect process of selection and presentation, carried out today by what Lyotard has termed the "techno-sciences", those institutions and technologies responsible for the manufacture of the purportedly value-free "real". Artists such as Hesse-Honegger operate in opposition to such technologically entrenched forms of representation. Making plainly visible in her modest aquarelles the structural mutations she sees through the lens of the microscope, Hesse-Honegger instigates a pause in the proceedings, bluntly disrupts the seemingly unstoppable chain of mutually supporting images produced by establishment science. The frozen moment of depiction found in these watercolours and drawings are a freeze-frame of a different order, literally allowing us a glimpse into a world the existence of which mainstream science strives to deny. Artists have often had to hold to this role as society's conscience or dissenting voice, defying the "naturalness" of nature as conventionally defined.

It is interesting, then, that Hesse-Honegger's challenge to the authority of scientific "truth" involves the redeployment of a "pre-photographic" means of expression. Since photography still promotes itself as having an intimate and inviolable relation to the real, the "primitive" medium of painting might easily be consigned to the dustbin of outdated technologies. Why paint something when it can instead be photographed? Why employ a subjective mode of recording when an objective means of storing information is at hand? I think a direct response to these questions is evident from a consideration of what exactly it is that Hesse-Honegger does when collecting and presenting information about the species she examines. Her pictures may be the result of numerous subjective choices but they are nonetheless true to the condition of the insect under scrutiny. Whilst Hesse-Honegger chooses to make a painting that shows the unnatural transformations in the animal's body, this zooming in upon deformity is in no way a false representation. Rather, it is a way of highlighting already extant anomalies, making them directly visible (a far cry from inventing them, as she has sometimes been accused of doing). Perhaps the increasingly popular computer-based manipulation of photographic images will eventually make it readily evident that photography's status as a kind of unmarked mirror of the real is completely false. Meanwhile, photography retains its place in the hierarchy of devices of realistic representation. Once such issues as those promulgated within Hesse-Honegger's practice are raised it is up to others to assess their validity, a task which will have to be concerned not simply with the truth of Hesse-Honegger's findings (the actual mass mutation of insects and what this implies), but with how our society constructs its picture of itself, as well as asking in whose hands the power to produce such a picture resides.

opposite
Cornelia Hesse-Honegger,
Negro Bugs. Corimelaenidae.
Visible tumours
Found near Three Mile Island,
Pennsylvania, USA 1992.
Photo: Peter Schälchli
© Cornelia Hesse-Honegger.

To suggest that all representations of the real are open to comparison and dispute is not, however, to imply that Hesse-Honegger's paintings can support just whatever interpretation of them a given viewer might choose to make. The pictures themselves are only one part of a broader activity that includes, it must not be forgotten, the discourse around the work, not least Hesse-Honegger's own public talks and interviews, but

also whatever debates are generated as a result of the existence and exhibition of the paintings. Science may deny the accuracy and implications of Hesse-Honegger's work as much as it likes but, by its own standards of verification or denouncement, it must deal with it. The account of how Hesse-Honegger came to make these pictures cannot be divorced from the watercolours themselves, and any attempt to do this would be a gross misrepresentation of her practice as a whole. Implicit within this body of work is a claim for painting's position as a still-plausible realism, and it is ultimately to artists such as Courbet and the Impressionists that Hesse-Honegger and her work should be connected, as opposed to, say, the Surrealists. Despite the superficially surreal imagery of some of these paintings they represent not imaginary animals but real ones, unembroidered with respect to their accuracy, whatever the technical dexterity involved in their making. When Courbet described himself as a realist he meant by this that it was his intention to show in his paintings the world as it actually was, neither glorified nor otherwise distorted. Similarly, the Impressionists aimed at a rigorous versimilitude. The claim to truth made within Hesse-Honegger's practice is its most emphatic assertion, and the concerns she raises can readily be expressed within figurative painting, since the effects of radiation are, in the cases she records, easily visible.

"At all times", observes Theodor Adorno, "the pictorial representation of nature seems to have been authentic only when it was *nature morte*: when it had the ability to interpret nature as an encoded historical message, if not as a message of death itself."[8] Adorno's italicised term points both to "dead nature" and to "still life", and if the passage does not specifically refer to Hesse-Honegger's paintings it might, however, be most pertinently applied. The tragically ambiguous phrase *nature morte* seems eerily apt, as does Adorno's noting of the authentic status afforded by those works holding an ecrypted historical signal or warning sign. Adorno further suggests that "The objectivity of a work of art can also be called its necessity."[9] Here too Hesse-Honegger's work might well form a most persuasive example, since it holds both to a directness of observation and to a point of political necessity. These two features make Adorno's comment readable at another level as well, one in which realism of expression combines with political validity in order to form an aesthetic "rightness" or formal validity.

8 Adorno, Theodor W, *Aesthetic Theory*, London: Routledge Kegan Paul, 1984, p. 100.

9 Adorno, *Theory*, p. 114.

There is, however, something subtly violent in the clash of aspects formed by the subject matter of these paintings and their precious, compact manner of execution. The formal beauty of Hesse-Honegger's images contrast sharply with what they show, which is the beauty of nature, its erstwhile formal orderliness, in acute dissolution. Here, notwithstanding their accuracy of rendition, a sense of the surreal does creep in, as though we are looking at creatures out of Lautréamont or Jules Verne. André Breton's stipulation that "Beauty will be CONVULSIVE or it will not be at all" is a claim in which one can, in the light of Hesse-Honegger's-Honegger's pictures, uncover an entirely other strand of understanding.[10] Painting beautiful watercolours of grotesquely deformed insects has itself a certain monstrosity, conceptually so if not necessarily at the level of the retinal. Poussin's famous painting showing *The Arcadian Shepherds* finding proof of

10 Breton, André, *Nadja*, New York: Grove Press, 1960, p. 160.

right
Cornelia Hesse-Honegger,
*House fly. (Mosca domestica
mutation—'aristapedia').* Fly
mutated by x-rays at the
Zoological Institute at the
University of Zurich. Part of the
legs grow out of the feelers, the
wings are bent and no longer
transparent, the eyes and body
are yellow. In addition the chitin
armour is more brittle than that
of wild flies, 1985-86.
Photo: Peter Schälchli
© Cornelia Hesse-Honegger.

corruption at the heart of what had appeared to be a paradise on Earth is another image to which Hesse-Honegger's work can be compared, for both artists show that within the uneventful, everyday order of things there may well lurk a darker force, its very presence implying total desolation. [11]

11 On this work by Poussin see Erwin Panofsky, "*Et in Arcadia Ego: Poussin and the Elegiac Tradition*", *Meaning in the Visual Arts*, Harmondsworth: Penguin, 1970.

Figurative painting is, finally, an odd medium in which to depict something that is in fact invisible, the radiation leaked from nuclear power stations. In order to record the deleterious consequences of this strange spectral energy Hesse-Honegger has followed a line of thought expressed by a renowned poet whose work one would hardly think to connect with her own. "*Paint,*" wrote Mallarmé in 1864, "*not the thing, but the effect it produces.*" [12] These words describe, perfectly if inadvertently, Cornelia Hesse-Honegger's critical and artistic project.

12 Stephane Mallarmé, quoted in Anthony Hartley, "Introduction", *Mallarmé*, ed. A Hartley, Harmondsworth: Penguin, 1970, p. ix (translation modified).

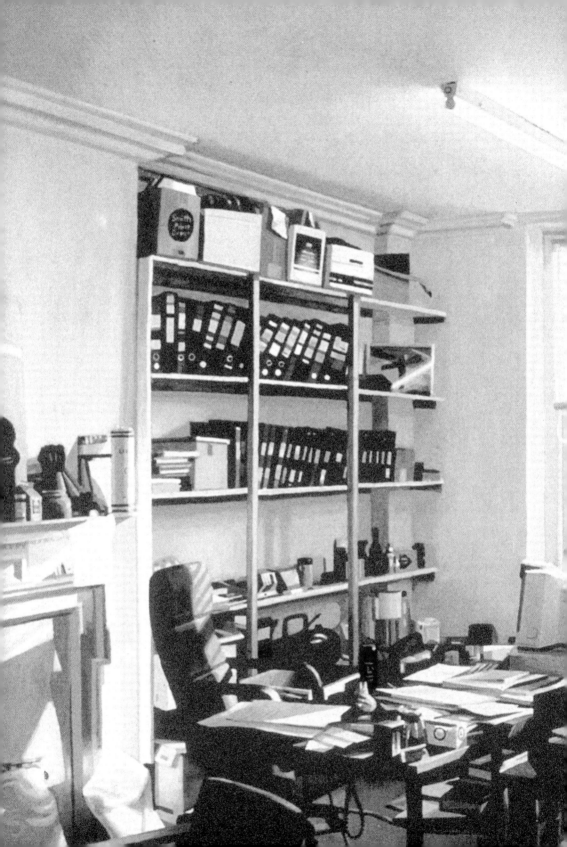

LOCUS +

**PROJECTS FROM
1993 TO 2000**

PAT NALDI & WENDY KIRKUP
SEARCH
A synchronised walk by the two artists in Newcastle upon Tyne city centre recorded on a 16 camera surveillance system installed by Northumbria Police. The resultant edited footage consisted of 20 ten-second sequences transmitted during the commercial breaks on Tyne Tees Television between 21 June and 4 July 1993. Commissioned in collaboration with the Second Tyne International.
Search and *Search: Newcastle and Adelaide* (the second a co-publication with the Experimental Art Foundation) are available in VHS, Beta and U-matic stock (PAL & NTSC formats).

LOUISE K.WILSON
THE MUSEUM OF ACCIDENTS
A performance installation examining the role of accidents in the evolution of technology and the role of technology in accidents. Wilson recreated a 1920s tea dance in the Great Hall of the Museum of Science and Engineering, which had formerly been a dining-room for employees and guests of the Co-operative Society. As an orchestra played, ballroom dancers swept past a screen which showed a continuous projection of a virtual flight between San Diego and San Francisco in real time (two hours) taken from the Microsoft Flight Simulator 5.0 computer package. During the 'flight' there was the constant possibility of experiencing an 'accident'. 27 August 1993.

previous page
Andrew Grassie *Locus+ Office*
Tempera on Paper,
145 x 200mm. 1999.

LLOYD GIBSON
CRASH SUBJECTIVITY

A figurative sculpture combining male and female, adult and infant dimensions, perched on a black ladder, the child's neck straining to look heavenward. Its wide hips, small waist and long legs suggested the body of a woman, yet its pubescent male genitals and shallow chest implied the body of a young boy.

The work was first presented in the bell chamber of the High Tower of All Saints Church, an eighteenth-century elliptical building, in Newcastle upon Tyne from 27 August to 6 September 1993. It was then relocated to two other radically different contexts. Firstly, from 4 to 6 March 1994, in the bell chamber of the rundown Carlisle Memorial Church, overlooking Carlisle Circus, an area of Belfast which sees the Catholic and Protestant communities living in close proximity to one another. Secondly, from 22 to 24 May 1995, in the glass rotunda of the Dublin Institute of Technology, built on the site of the Jacobs Biscuit Factory, occupied by the Irish Volunteers in the Easter Rising of 1916.
The Perplexities of Waiting ISBN 1 899377 04 2

MARK HAYWOOD
THE CITY MUSEUM OF ART AND DESIGN

A critique of aspects of postmodernity and design through four site-specific sculptures based on famous twentieth-century design classics which have been rendered dysfunctional and recontextualised as artworks in Newcastle upon Tyne. A five-foot long Sabatier knife (with original handle) was displayed on an outsize bread board in an allotment. A pair of Lobbs shoes, joined together with a single sole, were displayed in a fashion shop. A pair of Alessi kettles, sculpted in bronze, were displayed on a plinth at the Victorian-built Laing Art Gallery. A scale model of a Citroen DS was sculpted in clay and became gradually elongated as it was washed in a car showroom. From 27 August to 10 September 1993.

LANI MAESTRO, HENRY TSANG, SHARYN YUEN AND PAUL WONG.
FENG SHUI

A site-specific installation and performance by four Asian-Canadian artists, in which works were selected for, and presented in, All Saints Church using the ancient Chinese practice of *feng shui* (meaning wind and water in Cantonese). Feng shui is believed to be responsible for determining health, good luck and prosperity. In this instance, modifications were made to the interior space to ensure harmony, such as introducing an eight-foot-diameter pond stocked with carp and plants, and the placement of mirrors around an altar to correctly balance natural light. All the artworks used photo-based strategies and were concerned with aspects of the family. 27 August to 3 September 1993. In collaboration with On Edge, Vancouver.
Feng Shui ISBN 0-9694777-1-6

SUTAPA BISWAS
TO KILL TWO BIRDS WITH ONE STONE

A performance at the Plug In Gallery, Winnipeg, Canada, involving the artist networking with the local community in order to secure the loan of a 'senior sari' (a term affectionately used to describe a particular rank of individual donning such an article, generally a woman or man in their late forties onwards). The act of borrowing or lending a sari is an intimate one and required a sense of diplomacy. Twenty-five saris were positioned in four rows in the gallery. An accompanying soundtrack was broadcast of the artist's voice-over explaining the significance of the sari, the histories of the specific garments used in the performance and personal anecdotes of the donors. In collaboration with Plug In Gallery, Winnipeg, Canada 1993.

ANDRE STITT & DANIEL BIRY
WORKING ON THE BYPASS

Limited edition compact disc and booklet, released February 1994. Spoken poetry by Stitt, one of Europe's most confrontational and visceral performance artists, taken from a fifteen-year body of work, combined with compositions by classically-trained French composer and musician Biry.
A co-publication with ND (Texas).

MARK WALLINGER
A REAL WORK OF ART

Commissioned artist's multiple in edition of 50: die-cast equestrian statuette painted in the likeness of the horse, with the jockey wearing the artist's registered colours—violet, green and white (the colours of the Suffragette Movement). Proceeds from the sale of the statue contributed to the stabling and training costs of a two-year-old chestnut filly named *A Real Work of Art*, which ran in the 1994 flat season. Locus+ was registered as one-twelfth owner. In collaboration with the Anthony Reynolds Gallery.

JOHN NEWLING
SKELETON

A temporary site-specific installation in which the residue of approximately 80,000 template sheets of holy bread (each two-by-one-foot sheet marked by the holes left when the Eucharist wafer had been punched out) were stacked sporadically in the pews of All Saints Church, Newcastle upon Tyne. The fabric of the building was left untouched, except that it was systematically cleaned and any free-standing objects removed, a process which contributed to a sense of absence. Placed in front of each stack was a book printed by the artist which looked like a hymn book, except that it only reprinted those hymn lines which ended in a question mark. 31 March to 7 April.
Skeleton: Investigating a Site ISBN 1 899377 02 6

VIRGIL TRACY
A GOOD BOOK
A filofax insert of the transcribed speeches of evangelist preachers
recorded by the artist in Nottingham city centre's Market Square in
February and March 1994. Limited edition with filofax wraparound.

NOREEN STEVENS & SHEILA SPENCE
AVERAGE GOOD LOOKS
Image/text works produced during residencies. In Newcastle upon Tyne
Stevens and Spence worked with HIV/queer groups, researching
localised opinions about the gay community in the area of the Bigg
Market, Newcastle's busiest clubbing and bar area. They produced *REAL
Family*, an image of men drinking in a bar, with the caption "Aye, me
mam's a lesbian. So What?" which was featured in The Crack, the local
listings magazine.
In Liverpool and Manchester they worked with lesbian and women's
groups (in collaboration with It's Queer Up North and Signals Festival of
Woman Photography) and produced *Emma's Out*, a limited edition
poster and postcard using photomontage techniques.

NHAN DUC NGUYEN
TEMPLE OF MY FAMILIAR
Large mural painting (measuring 100 feet long by 16 feet high)
constructed from seventy interlinking panels, a visual autobiography
using Vietnamese and Buddhist iconography. The mural could be read
from either the left (a section which depicted heaven) or the right (which
depicted hell), and contained details of the artist's life including the
incident of his temporary loss of sight from a racist attack (Nguyen
began to work on the individual sections of this mural as a consequence
of this attack—it took a while for his damaged field of vision to
recuperate, and he could only work on a small scale). Presented in
Blackstaff Commercial Complex, Falls Road, Belfast, from 17 to 24
September 1994. In collaboration with On Edge (Vancouver) and Flax Art
Studios (Belfast).
Temple of my Familiar is available as a video documentary (by Paul
Wong) in VHS, Beta and U-matic stock (Pal & NTSC formats).

MAUD SULTER
PLANTATION
A videotape critique highlighting ethical issues relating to Western
medical practice, documenting the artist's attempts to introduce female
reconstructive surgery as a plausible alternative to standard surgical
practice. In collaboration with Plug In Gallery, Winnipeg, Canada.
October 1994.

MARY DUFFY
STORIES OF MY BODY
Performance monologue by Duffy which referenced disability issues, specifically the need to produce alternative definitions and perceptions beyond the term 'thalidomide'. The work was prompted by an initial visit to the artist's G.P., an experience which reminded her how she had been disempowered as a child, stripped naked, objectified and desensitised by the medical profession. Duffy's performance, in which she confronted her audience naked, was presented at Tullie House, Carlisle on 7 March and The Factory, Belfast on 10 March 1995 (in the latter case in collaboration with Catalyst Arts).

DON BELTON
POPULUXE/BLACKGLAMA
A semi-autobiographical performance drawing both on Belton's family experiences of growing up in America and the influence of broader cultural neologisms and depictions of race in the mainstream, specifically in the latter case the artist's fixation with Diana Ross and the Supremes. The 1960s populuxe movement was depicted in a series of slides projected large in the space, and the work culminated in Belton dressed up as Ross, miming to the hit "Baby Love". Presented at Catalyst Arts on 11 March and the Live Theatre, Newcastle upon Tyne on 15 March 1995.

DANIEL J.MARTINEZ
HOW TO CON A CAPITALIST
Street performance attempting to interrogate assumptions of public space and cultural hierarchy through audience confrontation and participation. In this case Martinez adopted the guise of a street hawker, the kind who eke out a living from the sale of cheap disposable items. However, his objects for sale were deliberately bizarre—potatoes with slogans stuck in them, wooden guns—and referenced hybrid interpolations between Western and Mexican culture. Martinez operated from a central site in Belfast on 13 March, and a number of geographically disparate sites in Newcastle upon Tyne from 15 to 17 March 1995.

STEFAN GEC
NATURAL HISTORY
Scanachrome portraits of the first six fire fighters to have died containing the Chernobyl disaster, presented on the ninth anniversary of the incident on 26 April 1995 on the roof of Pilgrim Street Fire Station until 12 May. In 1996 Gec visited with fire fighters from the City of Kiev Fire Service and Chernobyl Fire Service on a research trip to the Ukraine. Since then the work has toured to the Orchard Gallery, Derry (1995) South Hill Park Arts Centre (1996), the exterior of the SAW Gallery, Ottawa, Canada (1996), and the Oseredok Ukrainian Cultural Centre in Winnipeg, Canada (1998) in collaboration with the Winnipeg
Art Gallery. The latter exhibition also involved the presentation of a limited edition gold button (called *Once Removed*, it was cast from a tunic button given to Gec by the Chernobyl Fire Service) and presented to the Chief Fire Officer of the Winnipeg Fire Department.
This project and others by Gec, including *Buoy* (see below), are covered in *Trace Elements: Works from 1989-1995* ISBN 1 899377 05 0

IAN BREAKWELL
HIDDEN CITIES

Hidden Cities was a nationwide series of public guided tours of five British cities in which live commentaries were provided not by official tour guides but by five artists (who are also writers). The intention was to give a uniquely scripted view of each respective city and to uncover hidden cultural meanings beneath the conventional representation of history and heritage. It was initiated by the Laboratory, Oxford, who invited Locus+ to curate the event in Durham. Ian Breakwell gave a tour in two parts. The first was on board the Prince Bishop River Cruiser, which circumnavigated the Wear peninsula, with onboard microphone commentary by the artist who took his cues from landmarks along the journey. The second involved the tourists disembarking and proceeding on foot to Durham Cathedral, where Breakwell gave a reading from the penultimate chapter of Kafka's novel *The Trial*—"In The Cathedral"—from the main pulpit. 22 September 1995.

PHILIP NAPIER
SOVEREIGN

A videotape and video installation produced during a residency by Belfast artist Philip Napier in Vancouver, Canada. The video narrative finds analogy between urban layout and images of dental X-rays, feeding into the North American dental fixation and anticipates the intense construction work redefining the city of Vancouver. As survey, these teeth, animated by the camera, echo with the registers of generations of occupation, of history and of place. The Belfast teeth suggest a bared and tensed, gapped and broken urban landscape. The installation, shown at Video Inn on 28 October 1995, also incorporated unfurled destination rolls used by Vancouver's rapid urban transit system. In collaboration with On Edge (Vancouver).
Sovereign is available in VHS, Beta and U-matic stock (Pal & NTSC formats).

ALAN MOORE, DAVID J AND TIM PERKINS
THE BIRTH CAUL

A performance monologue by comic book writer Alan Moore (responsible for graphic novels including *Watchmen, From Hell* and *V for Vendetta*). Seated in the judge's chair of the (disused) Old County Court in central Newcastle upon Tyne, he referred to the birth caul—the torn piece of membrane wrapped occasionally around the newborn head—as a natal ticket stub, drawing on its talismanic qualities (many believe if kept, it will provide protection against drowning and provide safe passage). A continuous ambient landscape was provided by composer David J (of pop group Bauhaus), and aspects of Moore's narrative were further interpreted by Tim Perkins, seated below Moore.
The Birth Caul CD is co-published with Charrm records CHARRMCD22

SHANE CULLEN
FRAGMENS SUR LES INSTITUTIONS RÉPUBLICAINES IV

Fragmens sur les Institutions Républicaines IV was presented on the (disused) top floor of the Tyneside Irish Centre (originally a printers) from 7 to 16 June 1996, and consisted of 48 panels produced at that time (from an eventual total of 96). The paintings (6m x 2.5m) are of texts, reproduced by a painstaking transcription process, taken from the "Comms", communications originally written on cigarette papers and smuggled out of the Long Kesh during the 1981 hunger strikes in Northern Ireland.
Fragmens sur les Institutions Républicaines IV (Panels 1-48) ISBN 1 899377 09 3

STEFAN GEC
BUOY

Buoy is one in a series of works that take their inspiration and materials from a quantity of metal plate salvaged by the artist from Soviet Whiskey Class submarines which were broken up for scrap at the north east port of Blyth in 1989. Gec recast the steel producing eight large bells—called *Trace Elements*—which was commissioned by Projects UK for the TSWA Four Cities project. These bells were suspended from a wooden pontoon attached to the High Level Bridge that spans the River Tyne in the centre of Newcastle upon Tyne. At low tide the bells were exposed and at high tide covered completely allowing the metal to chime with its earlier role. During 1994-95 these bells were reinstalled on dry land as *Detached Bell Tower* in Glasgow, Helsinki and Derry.

Buoy consists of the recasting of the steel from the bells into a fully working, ocean-going buoy, a navigational aid which marks shipping lanes, dangerous marine objects and the entrances to safe havens. It fulfils the functions normally assigned to floating markers and is intended for use by international coastal authorities throughout northern European waters. *Buoy* was first unveiled on the quayside at the Museum of Hartlepool on the eve of the first Hartlepool Maritime Festival on 14th June 1996. In collaboration with The Laboratory (Oxford) and The Ormeau Baths Gallery (Belfast).

Limited edition maquette: 1:10 scale model of *Buoy*.

CORNELIA HESSE-HONEGGER
NACH CHERNOBYL & THE FUTURE'S MIRROR
After studying at the Commercial Art School in Zurich, Hesse-Honegger completed her training as a scientific illustrator at the Zoological Institute of the University of Zurich, the Zoological Station in Naples, and the Ecole Superieure des Beaux Arts in Paris. In 1986 Hesse-Honegger began to document the effects of the fallout from the Chernobyl disaster in the Ukraine. Her studies of insects and plant life affected by the radiation plume that spread over Europe revealed similar mutations to those observed under controlled laboratory conditions. Since then, Hesse-Honegger has continued this long term enquiry, travelling and collecting insects from the perimeters of nuclear power stations including Sellafield in the UK, Three Mile Island in the USA and the Canton of Aargau in Switzerland.
Two exhibitions of her paintings, respectively titled *Nach Chernobyl* and *The Future's Mirror* were exhibited in various venues: the Hancock Natural History Museum, Newcastle upon Tyne (1996), University Museum, Oxford (1996), Tullie House, Carlisle (1996/7), Leeds City Art Gallery (1997), Middlesbrough Art Gallery (1997), Woollaton Hall Natural History Museum, Nottingham (1997), Walter Phillips Gallery, Banff (1998) and Vancouver City Art Gallery (1998/9).
The Future's Mirror ISBN 1 899377 07 7

LOCUS+ 1993-96.
Publication covering first three years of Locus+ projects. Artists statements, documentation and critical writing. Foreword by Stuart Morgan. Launched Newcastle upon Tyne on 24 July 1996.
ISBN 1 899377 06 9

STEVE FARRER
THE CINEMA OF MACHINES
Farrer built a series of mechanical devices which playfully deconstructed the event of visiting the cinema, presenting an environment that referred to the cinema's fairground origins. These hybrid machines—both filming and projection—were sculptural projects in their own right, and also explored the tactile qualities of photo chemistry, light and mechanisms.
Exhibited as part of Cinema 100 at the Northern Gallery for Contemporary Art, Sunderland from 7 August to 14 September 1996.

JAN WADE & VANESSA RICHARDS
JAZZ SLAVE SHIPS, WITNESS, I BURN

Vancouver-based artist Jan Wade undertook a two-week residency in the western port community of Whitehaven in Cumbria, which was once England's fifth-largest slaving port. The site for the resultant event was the disused Jefferson Warehouse, an eighteenth-century bonded warehouse near to the docks with direct links to the slave trade. Wade's work focuses on altars as vehicles for worship, vessels of African spirituality as well as the symbolic reconciliation of the painful past of the African Diaspora. During the residency Wade constructed a large altar with several other smaller pieces, using both local materials and objects associated with the practice of Santeria (a mixture of Yoruban spirituality and Catholicism): horseshoes, 8-balls, dolls, 'Black Power' fists, etc. When Africans created a drum, they used wood from trees closest to the village as containers of the village's stories. Similarly, Wade used wood intended to 'find' and 'hold' the voices and stories of Whitehaven. On the evening of 12 October 1996 the public was invited into the site to examine the altar, and see a live performance by Vanessa Richards, who acted as her griot (storyteller), recounting the story of fictional composite Mary Christian Grassett (a young slave girl representing a number of different stories found by Richards in local archives). Afterwards, the audience carried the altar in a public procession to the harbour, where it was lowered into the sea for a symbolic voyage back to Africa; following the African custom of sacrificing ancestral objects to the home of the spirit world.

An amended version of the work was presented on 19 October 1996 at William Wilberforce House in Hull. On this occasion Richards' character took visitors on a tour through the house of the famous abolitionist, before the altars were carried, once again by the audience, to be dipped in a nearby ornamental garden pond.

An audio version of the project was presented at the grunt gallery, Vancouver on 8 January 1998.

Jazz Slave Ships, Witness, I Burn CD is co-published with Charrm records L+001

GREGORY GREEN
GREGNIK (PROTO 1)
The construction of a fully functional full-scale prototype communications satellite modelled on the former USSR's Sputnik. Green worked as artist in residence from 18 to 22 November 1996 in the Meadow Well Community Centre (an economically distressed area situated on the outskirts on Newcastle upon Tyne), where people could visit and watch him building the satellite. The basic intent of the project was to repeat the former USSR's Sputnik programme on an independent and alternative level, with the hope of producing a similar re-examination of the roles and relationships of the state, the individual and technology in contemporary global society. *Gregnik (Proto 1)* was the first stage, and Green intends to eventually launch the satellite in low-level short-term orbit above the northern hemisphere. Residents were also encouraged to have anecdotes about their community recorded at a temporary sound studio. These oral stories were then transmitted on an FM frequency broadcast from *Gregnik (Proto 1)* over a three-day period (25-27 November) over a seven-mile radius.
Limited edition maquette: 1:3 scale model of *Gregnik (Proto 1)*.
This project and others by Green is covered in *Manual II* co-published with The Cabinet Gallery (London). ISBN 1 899377 08 5

DAVID RINEHART
STUDIO 2020
Internet project, depicting a virtual artist's studio. Throughout 1996.

LIFE / LIVE
Stefan Gec, Gregory Green, Cornelia Hesse-Honegger, Paul Wong.
As part of the survey show of British art, Locus+ was invited to curate a section of the exhibition. Paintings by Hesse-Honegger, the limited edition maquettes of Green's *Gregnik (Proto 1)* and Gec's *Buoy*, and an installation by Wong titled *Chinaman's Peak: Walking the Mountain* was shown at la Musée d'Art Moderne de la Ville de Paris from 5 October 1996 to 5 January 1997, and at Centro Cultural de Belem, Lisbon from 31 January to 21 April 1997.
Catalogue published by Paris Musées in English/French ISBN 2-87900-322-9
Catalogue published by Centro Cultural de Belem in English/Portugese ISBN 972-8176-34-1

PAUL WONG
WINDOWS 97
An installation consisting of large backlit colour photographs of Queen
Elizabeth II and Chairman Mao bordered by flashing neon symbols: the
Union Jack, red star, AK 47 automatic rifle, money signs, bowl of rice,
new Hong Kong logo, a crown, Chinese calligraphy and the atomic
symbol. It was designed for the grand windows of the classical and
richly decorated Nash Room of the Institute of Contemporary Arts
overlooking the Mall, London. The exterior view of the work, when
viewed from the street, showed green, white and orange panels, the
colours of the Irish tricolour. It was shown from 29 to 31 May 1997, to
coincide with the transfer of power from Europe to China.
Windows 97 was a co-commission with ICA Live Arts, and was further
exhibited at the Site Gallery, Sheffield from 26 June to 10 July 1997.

LAWRENCE PAUL YUXWELUPTUN
AN INDIAN ACT SHOOTING THE INDIAN ACT
In September 1997 Native American Yuxweluptun shot copies of the
Indian Act under controlled conditions. The Indian Act was passed by the
Canadian government in 1868. It was based on 'New World' legislation
created by the sovereign British government which attempted to subdue
and control indigenous peoples in a racist and paternalistic manner.
On 13 September Yuxweluptun used a rifle to shoot copies of the Indian
Act at the internationally renowned National Rifle Association shooting
range at Bisley Camp (40 miles south of London). The event was hosted
by the Artists' Rifle Club.
On 14 September Yuxweluptun used a shotgun to shoot copies of the
Indian Act at Healey Estate, situated on 2,500 acres of private land in
Northumberland.
Limited edition multiples produced from the performance:
Boxed set Bisley Camp—expended rifle cartridge (edition of 20)
Boxed set Healey Estate—expended shotgun cartridge (edition of 20)
Boxed Healey shotgun (decorated), shot copy of Indian Act, expended
cartridges (edition of 3)
Boxed Indian Act—one shot copy from Bisley Camp and Healey Estate,
with cartridges (edition of 3)
An exhibition of these multiples was presented at the grunt gallery,
Vancouver from 6 to 31 January 1998.

ROSELEE GOLDBERG
HOW TO PERFORM: SOME THINGS I HAVE LEARNT
A commissioned lecture on highlights from the history of performance
art in the 20th century by RoseLee Goldberg. Presented at three venues
in November 1997: Ruskin School of Drawing & Fine Art Oxford,
University of Wales, Institute Cardiff and The Drill Hall, University of
Northumbria at Newcastle upon Tyne.

PAUL ST. GEORGE
MINUMENTALS

A Minumental is a monumental contemporary sculpture made to a minumental scale. Each Minumental sculpture is always an (arbitrary) 10.5 cm x 10.5 cm x 10.5 cm, and the complete project will include about 40 iconic sculptures of the twentieth century, reduced to a common size and available to be collected and viewed in any one place. Minumentals question the supremacy of scale, subvert the authority of ownership and challenge the condition of uniqueness. Minumentals foreground the physical experience of sculpture and address issues of reference and appropriation with reverence and irony.

Minumental Angel of the North was launched at the Angel View Inn, Low Fell, Gateshead, on 16th February 1998 (coinciding with the launch of Anthony Gormley's *Angel of the North*).

Minumental sculptures to date are: *Minumental Angel of the North, Minumental Brillo Boxes, Minumental Cave, Minumental Diagonal, Minumental Equivalent VII, Minumental Fat Chair, Minumental Ghost, Minumental Giant (Burnt Match), Minumental Halifax Slate Circle, Minumental House of Velti, Minumental Impossibility, Minumental Oak Tree, Minumental Order (I.T.), Minumental Stack, Minumental Table with Pink Cloth, Minumental Tilted Arc, Minumental Total Equilibrium, Minumental Triangular Pavilion, Minumental Wrapped Reichstag, Minumental 20:50.*

Minumental ® is a Registered Trademark of Paul St George. Each Minumental is protected by UK Design Right.

For further details contact: Paul St George by e-mail: paul@minument.demon.co.uk

or visit the web-site: http://www.minument.demon.co.uk/

CATHY DE MONCHAUX
THE DAY BEFORE YOU LOOKED THROUGH ME
A permanent public artwork for Cullercoats Metro Station, commissioned by Nexus as part of the ongoing Public Art in Public Transport Programme, incorporating a use of photography on a monumental scale. A digitally manipulated image, 3.8m high x 6.2m wide, shows a deserted railway station after an important ceremony. An abandoned red carpet on the platform, folded by the winds and sodden from the rain, spirals onto the tracks; the lights of a train can just be seen, arriving over the horizon. This stark, melancholic image reminds the viewer that the activity of travel involves expectation, disappointment and celebration. Perspex placed over the image reflects the viewers' gaze, who can see themselves inserted into the tableau, standing on a red carpet, awaiting a journey of their own. Installed in March 1998.

MULTIPLES
Exhibition of Stefan Gec multiples and Locus+ publications at Art Metropole, Toronto, Canada from 1 June to 31 July 1998.

ANYA GALLACCIO
TWO SISTERS
A temporary site-specific work curated by Locus+ at the invitation of the Artranspennine98 festival. Artranspennine98 featured a number of site-specific commissions across the Transpennine region.
On 22 May 1998 *Two Sisters* was installed in the silt bed by the Minerva Pier in Hull; a six-metre high, two-and-a-half-metre-diameter, column of chalk bonded by plaster. Once in position, the tidal flow of the River Humber continually modified the shape of this mineral tower over the following weeks. Twice a day the column was exposed at low tide and virtually concealed at high tide, displaying the effects of erosion from the action of the waves (and, to a lesser extent, the wind and rain). Gradually, the smooth vertical plane of the artwork became fractured as lumps of chalk jutted irregularly from its surface, occasionally falling into the river. On 22 June the incremental effects of the water resulted in *Two Sisters* collapsing into the silt bed. This was the inevitable result of Gallaccio's original intention to explore the mutability of the site by constructing an imposing yet transient structure. The physical scale of *Two Sisters* now only exists in the memory which, like the Hull coastline, continually shifts, defying easy definition.
This project and others by Gallaccio is covered in *Chasing Rainbows*, co-published with Tramway (Glasgow). ISBN 1 899 551 15 8
Special edition hardback (100) ISBN 1 899 551 16 6

LAURA VICKERSON
FAIRY TALES & FACTORIES
A site-specific installation commissioned for Farfields Mill in the market town of Sedbergh, Cumbria. Farfields Mill was built in 1827 and closed permanently in 1996, after 169 years of linen production. The artwork consists of a hooded cape, 12 foot wide with a 70 foot train, constructed from hundreds of thousands of red rose petals individually pinned to organza. Overall production took place over three months, by female assistants who were paid on an hourly rate. The final part of the production took place with the assistance of the Sedbergh Stitchers, a local womens group, culminating in the installation of the work on the top floor. In addition to the manufacture of the cape, Vickerson recorded conversations between the women on site as well as compiling additional oral histories, folk tales and songs relating to the Mill, local industry and the village. These recordings served as ambient sound in the final exhibition; a documentation of process, a whispered archival record providing a counterpoint to the fantastic and surreal nature of the work itself.
On-site production was from 10 to 16 March, and the finished garment was exhibited as part of the Sedbergh Spring Fair (which Vickerson officially opened as Guest of Honour) on 20 and 21 of March 1999.
The artwork was also exhibited at the Holden Gallery, in Manchester Metropolitan University, from 25 March to 8 April 1999.

JONTY SEMPER
KENOTAPHION
An anthology of all the existing official recordings of the two-minute silences from Remembrance Sunday during this century. The silences (which are marked—in those cases where the full recording is still available—by the chiming of Big Ben at the beginning and a cannon shot at the conclusion) will be collated in chronological order. The Whitehall ceremony was documented, filmed and broadcast by different organisations; Pathé News, Gaumont British, Reuters and the BBC amongst others. Although the first ceremony took place in 1919, no official audio recordings exist from before 1928.
The collected audio work is distributed using MP3 technology, allowing computer users to download the material onto their hard drives.
Artists multiple in an edition of 50. Signed and numbered seven inch vinyl record. The commemorative one-minute silence recorded in Hyde Park Saturday, 6 September 1997 during the funeral of HRH Princess Diana.

n
LLOYD GIBSON AND MARK LITTLE

In 1942 a canister containing anthrax was exploded over Gruinard Island off the NW coast of Scotland as part of a secret MOD WW2 experiment in biological warfare. It remained a forbidden zone until the MOD declared the island safe for limited grazing in 1988 following a two-year decontamination programme (although total de-contamination may in fact be impossible). The 1942 Gruinard experiment was code named *n*. Artist Lloyd Gibson and writer/critic Mark Little are proposing the placing of a small figurative sculpture of a child on the island. The sculpture would be constructed from what are known as 'smart materials' or Shape Memory Alloys (SMA's) which have molecular memories at predetermined temperatures. In this case pre-stressed nickel and titanium will be used. This sculpture is constructed of materials whose memories were set at temperatures above and below the average temperature of the island; consequently the sculpture will distort, change and revert to its natural shape. Time-lapse cameras record the sculpture's deformations and reformations over an extended period. The sculpture will be abandoned, and will gradually deteriorate and embed itself into the landscape. The artwork will not be accessible to the public, who will only learn of it by seeing the film or via a public relations campaign; works of such a nature tend to encapsulate either controversial or imaginative qualities which allow them to effectively become 'larger' than their original physical size, conferring upon them iconic or mythic status.

In parallel, and integral to the project, is a publication that fully documents the research, fabrication and placement of the sculpture. The book will also contain critical essays addressing various aspects of the meaning of the work; the use of place as a metaphor for the political or social body. Furthermore, the physical material of the book itself (paper, hardback linen bound in a linen slip case, inks, spot varnishes), will also be infused with temperature controlled aromatic or spectral smart technology. This means that the ambient or body temperature of anyone handling the book/object triggers responses from its surfaces; change of colour or emissions of different aromas. The publication will be in circulation long after the original sculpture has deteriorated.
n ISBN 1 899377 15 8

LOCUS SOLUS

NOTES ON CONTRIBUTORS

Glenn Alteen is a writer, curator and director of the artist-run space grunt in Vancouver. Alteen has written on Canadian art and has published in *Parachute*, *Video Guide*, *Inter*, *Artichoke*, and *FUSE* magazine. He has curated a number of larger performance projects including First Nations Performance Series (1992), *Queer City* (1993), *HALFBRED* (1995). *POSITIVE+* (1997) and *Live at the End of the Century* (1999).

Paul Bonaventura has been Senior Exhibitions Coordinator at the Whitechapel Art Gallery in London and a Senior Visual Arts Officer at the Arts Council of Great Britain. He is now the Senior Research Fellow in Fine Art Studies at the University of Oxford.

Helen Cadwallader is a public art consultant dealing in all aspects of public art commissioning, from research, curating and project management to development and strategic advice. From 1994-99 she managed the BAA art programme which included Heathrow, Gatwick and Glasgow airports. Since 1995 she has been an executive committee member of Public Art Forum. She is a freelance editor and critic and lives in London.

Pauline van Mourik Broekman is an artist and co-editor of *Mute*, the culture and technology magazine. Aside from contributing to *Mute*, she has written for various publications, including *Andere Sinema*, the Nettime anthology *ReadMe!* and *Somewhere*, a catalogue of 'net works' by Nina Pope and Karen J. Guthrie. She lives and works in London.

Gavin Murphy is a writer based in Belfast who has recently completed a doctorate on painting and political conflict in Northern Ireland at the University of Ulster. He is an Associate Lecturer in History of Art at the Open University.

David Musgrave is an artist and writer based in London. His writing has appeared in *Art Monthly* and *Untitled* and he is to be included in the *British Art Show 5*.

Andrew Patrizio is a curator and writer, and is currently Director of Research at Edinburgh College of Art. Previously Exhibition Organiser at The Hayward Gallery, his *Contemporary Sculpture in Scotland* has recently been published.

Niru Ratnam is an art historian and freelance journalist. He is on the editorial board of the journal *Third Text* and a contributing editor of the fashion magazine, *scene*. He has written for a wide variety of magazines including *frieze*, *New Left Review*, *Art Monthly* and *Maxim*. Currently he is coming to the end of seemingly endless years of research on the work of Black British and Asian British artists.

Julian Stallabrass is lecturer in art history at the Courtald Institute of Art, and the author of *Gargantua: Manufactured Mass Culture* (London, Verso 1996) and *High Art Lite: British Art in the 1990s* (London, Verso 1999).

Peter Suchin is a critic and painter. His writings have appeared in many publications, including: *Variant*, *Mute*, *Art & Design* and *Art Monthly*.

LOCUS SOLUS

COLOPHON

Book designed by
Maria Beddoes & Paul Khera
assisted by Owen Peyton-Jones

Photographs of Newcastle
cover and section dividers
site, identity by PK+MB
technology by Jon Bewley

Printed in the
European Union

ISBN 1 901 033 61 9

Locus+
17, 3rd Floor Wards Building
31-39 High Bridge
Newcastle-upon-Tyne
NE1 1EW

T 0191 233 1450
F 0191 233 1451
E locusplus@newart.demon.co.uk

Locus+ is a company limited by
guarantee no. 2939638.
Registered office as address

Locus+ is funded by
Northern Arts and the
Arts Council of England

Further documentation and
critical writing on these and
future Locus+ projects can be
found on the regularly updated
website: www.locusplus.org.uk.

Black Dog
Publishing Limited
PO Box 3082
London NW1 UK

Architecture Art Design
Fashion History Photography
Theory and Things

4AISA